SUMMARY

CATALOGUE OF

European Paintings

IN THE

J. PAUL GETTY

MUSEUM

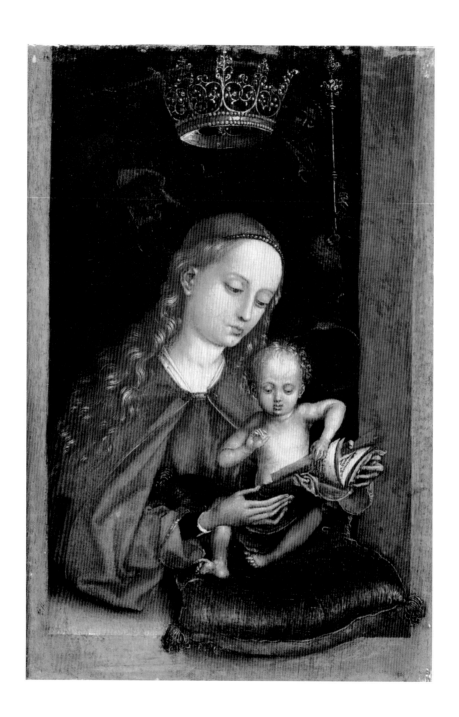

SUMMARY

CATALOGUE OF

European Paintings

IN THE

J. PAUL GETTY

MUSEUM

David Jaffé

THE J. PAUL GETTY MUSEUM

LOS ANGELES

Christopher Hudson, Publisher

Mark Greenberg, Managing Editor

Shelly Kale, Editor

Leslie Thomas Fitch, Designer

Elizabeth Zozom, Production Coordinator

Typeset by G & S Typesetters, Inc.,

Austin, Texas

Printed by Southern California Graphics,

Culver City, California

On the front cover:

JACQUES-LOUIS DAVID

Suzanne Le Peletier de Saint-Fargeau [detail]

see p. 33

Frontispiece:

MARTIN SCHONGAUER

The Madonna and Child in a Window

see p. 116

Library of Congress Cataloging-in-Publication Data

J. Paul Getty Museum.

 Summary Catalogue of European Paintings in

 the J. Paul Getty Museum / David Jaffé

 p. cm.

 ISBN 0-89236-481-5 (paper)

 1. Painting — California — Malibu — Catalogs. 2. J. Paul Getty

 Museum — Catalogs. I. Jaffé, David, 1953–1953. II. Title.

 N582.M25A595 1997

 750'.74'79493 — dc21 97-16882

 CIP

Contents

Foreword

THIS CONCISE CATALOGUE of our European paintings, issued at the opening of a new Getty Museum, is a kind of progress report on a collection that has been changing rapidly.

The largest section of the new Museum is a suite of twenty daylit galleries for European paintings. These were planned a dozen years ago in the hope that pictures could be bought in the intervening years that would justify them, and a major effort was launched to do so. Since 1982 the Museum has been able to add 172 pictures to the generally modest paintings bought by J. Paul Getty himself and to the acquisitions made by the Museum during the years in which its purchase funds were modest. This has made a dramatic change in the collection on exhibition—perhaps the most exciting of many transformations brought about at the Museum during these years.

Getty was fairly indifferent to paintings. He much preferred to concentrate on Greek and Roman antiquities and on French furniture and decorative arts. He made up for the short shrift he gave to pictures, however, by making a huge bequest to the Museum Trustees in 1976. The income has allowed the Museum to make great improvements in its holdings: to form entirely new collections of drawings, illuminated manuscripts, sculpture, and photographs, as well as strengthen its three original collections of antiquities, decorative arts, and paintings. (The income from the bequest has also permitted the creation by the Getty Trust of five new organizations to foster scholarship in art history and the humanities, conservation of art and architecture, and art education, and to make grants.)

Paintings have required the largest allocation of the Museum's purchase funds during this time of growth. Money alone could not guarantee success,

of course, since the pool of masterpieces has mostly dried up, competition is fierce, and European countries have become more protective—and they have gained the will and ability to buy. Though dramatically improved, the Getty collection of paintings still reveals its immaturity in the uneven distribution of great works; today it has a hybrid character, partly reflecting the taste of J. Paul Getty but very largely embodying the judgment of four different curators across a thirty-year span. There are now great paintings in every gallery, if not on every page of this book, and the Museum is still young. Many more years of astute purchases will surely transform the collection yet again.

Specialists often remark on the exceptionally fine condition of most Getty paintings. This is a matter partly of the curators having held to a high standard of preservation for potential acquisitions, and partly of the keen judgment and skill of Andrea Rothe, Mark Leonard, and their colleagues in the Museum's Department of Paintings Conservation. An important influence on both choices and tactics of paintings acquisitions has been exercised since 1984 by the Associate Director and Chief Curator, Deborah Gribbon, herself a paintings specialist.

The curators who built the collection have earned the largest share of our gratitude: Burton Fredericksen, Myron Laskin, George Goldner, and David Jaffé. I want to thank the latter in particular for having assembled this book. He had help from Dawson Carr, Denise Allen, Jennifer Helvey, Arianne Faber-Kolb, Stephanie Schrader, François Marandet, Carl Wuellner, and Sunyoung Ahn, who have been making a thoroughgoing review of the department's records. We hope that the book will be useful to specialists and interesting as well for all admirers of European art.

John Walsh
Director

Introduction

THIS SUMMARY CATALOGUE is a photographic survey of the paintings collection of the J. Paul Getty Museum. Of the 413 works in the present collection, 207 were acquired by J. Paul Getty, the Museum's founder, from around 1930 onward. The rest of the collection was acquired by the Museum after Getty's death in 1976. This publication guides the reader through the collection, providing the briefest of biographical information and data for each picture. The entries are organized alphabetically by artist. Inventory numbers include date of acquisition, so that, for example, 79.PA.2 means that the work was acquired in 1979 or possibly transferred from Getty's private collection in that year (some forty paintings from Sutton Place, Getty's estate in England, were given to the Museum after his death).

The previous Summary Catalogue, compiled by Burton Fredericksen, was published in 1972. Several editions of *Masterpieces of Painting* have been published in the meantime, recording many of the purchases made since the earlier catalogue; *The J. Paul Getty Museum Journal,* has regularly recorded acquisitions since 1984. Around one hundred pictures in the collection have been sold or traded, mainly at a few significant auctions: at Christie's London and New York in 1980, Sotheby's London in 1989, and Christie's New York in 1992.[1] The following introduction describes the development of the collection, with emphasis on the core of paintings purchased by its founder, and then briefly summarizes the acquisitions made by the Museum under four successive paintings curators.

The Getty Museum was opened in 1954 in Getty's house in Malibu. The funds he devoted to the acquisition of antiquities, French decorative arts, and, lastly, paintings were minor compared to his financial worth. On his death, his

trust was endowed with stock worth $700 million. These funds became fully available only in 1982, when lawsuits were finally settled. Since then the Getty Trust has come to support a number of different programs in the arts in addition to the Museum itself. While the Museum has been given great spending power, it has never been the intention to create a collection of the size or magnitude of the great European or American museums, such as the Metropolitan Museum of Art in New York, the Louvre in Paris, or the National Gallery in London.

Both the J. Paul Getty Museum and its California sibling, the Norton Simon Art Foundation, were latecomers to that grand tradition of American private museums, such as the Isabella Stewart Gardner Museum in Boston and the Frick Collection in New York. Unlike their East Coast antecedents, however, these Californians, Getty and Simon, consciously began to build public museum collections (Simon between 1964 and 1975, Getty briefly around 1953, but in the area of paintings only after 1970). In Getty's case both the decision to open his collection to the public in 1954, and the preparations for the new museum building, in the form of a Roman villa, that opened in Malibu in January 1974, corresponded with active phases of buying paintings, while between 1957 and 1967 he did not buy paintings for the Museum but rather acquired for his own houses, especially Sutton Place.

J. Paul Getty's personal interest as a collector was focused on antiquities and French furniture rather than on paintings. He approached paintings more like a businessman, and his acquisition of them was often characterized by a search for bargains and great discoveries. The prices he was willing to pay for paintings reveal how his perception of their market value directly influenced his acquisition strategy.[2] Getty's astuteness was grudgingly acknowledged by Edward Fowles, the Paris director of the famous art-dealing house Duveen Brothers, who in 1939 saw Getty as "a man who bought at investor's prices, that is to say, about the average dealer's price."[3] Eleven years later Fowles assessed Getty as, "rich, but very close, someone who carefully studied prices, mostly from sales catalogues."[4]

Getty made several shrewd and important purchases that have remained

strengths of the collection: Thomas Gainsborough's *James Christie* (bought for $26,522 in 1938) and William Adolphe Bouguereau's *Young Girl Defending Herself against Eros*. The Bouguereau was acquired in 1941 for $1,700 together with George Romney's *Mrs. Anne Horton, later Duchess of Cumberland*.[5] Getty secured the impressive Rembrandt *Saint Bartholomew* (for $532,000 at Sotheby's London on June 27, 1962), one year after Duveen had attempted unsuccessfully to persuade him to buy Rembrandt's *Aristotle Contemplating the Bust of Homer* from the Erickson collection, which fetched a world-record price in the November sale.[6] Getty apparently found that Rembrandt too expensive and waited until a cheaper alternative appeared on the market a year later. He continued to build strength in portraiture by purchasing Paolo Veronese's *Portrait of a Man* (for $124,000 in 1964) and a splendid Anthony van Dyck, *Agostino Pallavicini* (for $490,301 in 1968). He outbid the Louvre to buy Georges de La Tour's *Musicians' Brawl* (at Christie's London on December 8, 1972, for $942,078), and he must be credited with pursuing several of the most important paintings ever targeted by the Museum. His attempt to purchase Titian's *Diana and Actaeon* for the auction price of $4,000,000 was thwarted by the successful fund-raising appeal in 1971 by the National Gallery in London, and he was outbid in 1951 on Paulus Potter's superb *Piebald Horse*, which Myron Laskin was able to secure for the collection in 1988.

As we know from his own writings, Getty's motives as a collector of paintings were complex and changing. Occasionally during his early years he appears to have wanted mostly decorations, such as in his purchase of a large group of paintings by the Spanish artist Joaquín Sorolla y Bastida (1863–1923).[7] Sorolla's impressionistic *Wounded Foot*, which cost only $1,515 in 1933, has always been a popular work, and Getty might have been pleased to learn that at public auction in 1981 prices for works by Sorolla reached one million dollars for the first time.

Getty's ambitions, shared by many of us, included discovering a great lost or unknown work. As he became more serious about collecting paintings, he relied more on dealers and advisors, making it more difficult for us to judge his own role in the choice of acquisitions. Unlike Norton Simon, who was

even more actively acquiring paintings at an earlier date, Getty was always a buyer and very rarely a seller. Christie's found this out when they made repeated attempts to wrest Gainsborough's portrait of *James Christie*, the auction house's founder, away from Getty. Fearing a postwar slump, however, he did once consider selling his "art property," as we know from a letter he wrote to Duveen.[8]

The need to know exactly what he was buying led Getty to rely on experts and to delight in historical fact, both of which proved to him a painting's authenticity and importance. This was shown, for instance, in 1943, when he offered Rembrandt's *Marten Looten* (bought in 1938 and given to the Los Angeles County Museum of Art in 1953) and Gainsborough's *James Christie* to the Los Angeles County Museum of Art for its exhibition of *Masterpieces of Art from Los Angeles Collections*. In extending the loans, Getty characteristically wrote, "According to Professor Van Dyke in his work on Rembrandt, [the portrait] is one of 45 Rembrandts which are unquestionably and entirely by the master's hand. . . . The [portrait of James Christie] was painted by Gainsborough and given to his friend, Christie, the founder of Christie's, in order that Christie could hang it up in his showrooms as an example of Gainsborough's skill. It was also exhibited at the Royal Academy in 1778, so we may conclude that Gainsborough himself thought well of it."[9]

Provenance and the opinion of experts were to remain major influences on Getty's decisions to buy. As we shall see in his quest for a Rubens, price often emerged as the barrier that prevented him from triumphing. Getty rejected Duveen's offer of Rubens's *Spinosia Doria* in 1939 because he thought the price unreasonable. In 1954 his attitude remained unchanged, for when faced with the $150,000 price tag, Getty countered with a mere $50,000, claiming that early Rubens prices had weakened.[10] The magnificent portrait went to the National Gallery of Art in Washington, not to Malibu. Getty then focused his energy on more mature works by Rubens. The next year he acquired the *Death of Dido* for $20,000, despite initially recording in his diary that "the subject [death] is not pleasing." On April 14, 1955, Getty wrote in his diary with evident satisfaction: "[the art historian Alfred] Stiebel thought my Rubens very fine. He preferred it to the Duveen Rubens. I offered a big price for the

Duveen Rubens in 1938 and again in 1954. In Stiebel's opinion I now have the better Rubens." In 1957 he bought Rubens's *Andromeda* for $37,000, which, like the *Death of Dido*, featured a female nude, a subject for which he had a predilection.

Anecdotes testify to Getty's frequent soliciting of advice, be it asking the renowned art historian E. H. Gombrich to examine Rubens's *Death of Dido* or telephoning the Rubens expert Julius Held to find out what exact percentage of Rubens's *Diana and Her Nymphs on the Hunt* was autograph (that is, painted by the artist himself rather than his workshop assistants). Getty had always wanted a great Rubens, and having seen his bid of $600,000 fail to secure the Duke of Westminster's *Adoration of the Magi* in 1959, he rebounded, spending $350,000 two years later on the *Diana*.[11] This Rubens represented a major purchase, which was why he wanted to know just how much of the Flemish master's own hand he was getting for his money. Getty did seek advice from good scholars, but in contrast to the great success he had with Rubens's Dutch contemporary Rembrandt, he was not lucky with the Flemish master.[12]

Because he was ill served by his advisor Bernard Berenson, Getty's collecting of Italian painting was erratic. He began a correspondence with the venerable connoisseur after reading his book *Aesthetics and History in the Visual Arts* (New York, 1948). In a letter of November 21, 1952, Getty discreetly tested Berenson's expertise by enclosing two photographs identified as "My only Italian pictures." Getty noted that one of the paintings—Raphael's *Holy Family* (*Madonna di Loreto*)—had an illustrious provenance, being from the Bourbon collection at Frohsdorf.[13] In reply Berenson wrote to Getty's friend Ethel Le Vane, "I liked his Girolamo di Benvenuto . . . and don't think his Raphael was by the master's hand. To me it looked like a number of copies."[14] Informed of Berenson's view, Getty wrote back, "My mind is at rest now as to their origins," but the copy of the *Madonna* was to haunt him for many years to come.[15] It was widely accepted and exhibited as a Raphael in London's National Gallery in the 1960s, and Getty, in *The Joys of Collecting*, trumpeted the £40 ($200) buy as his great discovery. Unfortunately, history has been less kind. The research of his curator, Burton Fredericksen, led to the discovery

that the Musée Condé at Chantilly has the original version of this Raphael composition. A similar fate befell the *Nativity* by Benvenuto di Giovanni, which cost Getty a mere $1,500 but is now given to the artist's son, Girolamo di Benvenuto.

Stung by the negative reaction of the Los Angeles County Museum to the evaluations attached to his offer of a group of Italian paintings, Getty wrote to Berenson again on September 23, 1953, that he would "never buy another Italian Picture unless you tell me it is absolutely first rank." He continued, "The next Italian painting I buy will be one of the 100 greatest masterpieces or I don't buy it." Getty did act on Berenson's opinions in the following years, but not with good results. When Berenson recommended the purchase of Titian's so-called *Gutekunst Magdalene*, he failed to reveal that he had had a long-standing arrangement with the dealer.[16] Ironically, Getty's own instinctive reaction to the *Magdalene* was accurate; he recorded in his diary in July 1955 that it was "not very attractive, many similar versions, not in the books." Given these objections, it is remarkable that Getty purchased the painting, which is now acknowledged by scholars to be by Titian and his workshop.

On occasion, opportunity also lured Getty away from collecting Italian works. In March 1956 he confessed to Berenson, "I just got at auction a Degas oil painting of dancers, a Monet, and a Renoir. I don't expect to buy any more Impressionists. I just wanted a sample of the school. I'm true to Renaissance painting especially Italian." Despite the advice of Berenson, and later Federico Zeri, none of Getty's Renaissance buys can really be called masterpieces, and his bargain Impressionists were sold at auction in 1980 and 1989.[17]

In May 1965 Burton Fredericksen was appointed the Museum's sole curator. Fredericksen's tenure, which lasted until 1984, may be seen as the wilderness years in terms of buying power, but many of his acquisitions, especially after the Trustees got the use of the Getty endowment in 1982, were solid and exciting: Simone Martini's *Saint Luke*, Gentile da Fabriano's *Coronation of the Virgin*, Masaccio's *Saint Andrew*, Dosso Dossi's *Mythological Scene*, Jean-Étienne Liotard's *Maria Frederike van Reede-Athlone*, Hendrick ter Brugghen's *Bacchante with an Ape*, Claude Monet's *Still Life with Flowers and Fruit*, Rem-

brandt's *Old Man in Military Costume*, and Jacob van Ruisdael's *Two Watermills and an Open Sluice*. These works gave the paintings collection a backbone, while astute buying in sums under six figures gave it breadth and diversity. This was the foundation of a serious paintings collection. (Equally impressive is the Provenance Index, which Fredericksen, its director, established while researching his purchases. Now part of the Getty Information Institute, the Index grows increasingly valuable as a tool in tracing the ownership lineage of a work, thereby helping to establish its authenticity.)

Since 1983 the policy of the Museum has continued to be to collect only European paintings before 1900. In 1983 the president of the Getty Trust, Harold Williams, oversaw impressive joint purchases with the Norton Simon Art Foundation of two works, by Nicolas Poussin (*Holy Family*) and Edgar Degas (*Waiting*), which are rotated every two years between the Norton Simon Art Foundation and the Getty Museum. In 1984, the year after he became director of the Museum, John Walsh hired a new curator of paintings, Myron Laskin, who undertook a diversification of the collection into new areas. The fact that Walsh and Deborah Gribbon, the chief curator, were both specialists in European paintings gave greater urgency to the search for important pictures. Laskin felt that the now well-funded Museum was in a position to explore unfamiliar areas, such as nineteenth-century Scandinavian, British, Belgian, and German painting, along with the more commonly admired French art of the nineteenth century. Paintings by Leo von Klenze, Christen Schjellerup Købke, Edvard Munch, and James Ensor were acquired, as well as major works by Jacques-Louis David, Gustave Courbet, Jean-François Millet, and Paul Cézanne. Valuable additions to the Old Master collection included Andrea Mantegna's *Adoration of the Magi*; Giovanni Girolamo Savoldo's *Shepherd with a Flute*; Francesco Salviati's *Portrait of a Man*; Nosadella's *Holy Family with Saints Anne, Catherine of Alexandria, and Mary Magdalen*; Anthony van Dyck's *Thomas Howard, 2nd Earl of Arundel*; Philips Koninck's *Panoramic Landscape*; Pieter Jansz. Saenredam's *Interior of Saint Bavo, Haarlem*; Pieter de Hooch's *Woman Preparing Bread and Butter for a Boy*; and Jean-François de Troy's *Before the Ball*. Laskin also secured a remarkable group of

nineteenth-century oil sketches by Pierre-Paul Prud'hon, Jean-Léon Gérôme, and Théodore Géricault. Laskin's collecting was deliberately focused on the long term, anticipating future taste, and it is therefore not surprising that some of the works he acquired are only now gaining an increased admiration, or that the National Gallery in London and the Louvre followed his lead by collecting Danish paintings.

Appointed in 1990, George Goldner (who also founded the Museum's drawings collection) brought the focus of acquisitions back to works by great mainstream artists, such as Bernardo Daddi, Jacopo Pontormo, Sebastiano del Piombo, Titian, Domenico Fetti, Peter Paul Rubens, Gerrit van Honthorst, Guido Reni, Édouard Manet, and Vincent van Gogh. He had a more focused vision for the collection and was determined to place the Museum at the front of the art market by aggressively pursuing works even when, in order to buy a greater picture, he had to sell lesser ones. He fulfilled with distinction the mandate to secure great works by acclaimed artists.

Since my arrival in 1994 the Paintings Department has continued to search for major works. The building of the new Museum has provided the opportunity to arrange a chronological installation, which has made us more aware of the balance of the collection. Efforts to enrich the holdings of French eighteenth-century works have been slow, but the acquisition of pastels by Charles-Antoine Coypel, Maurice-Quentin de La Tour, and Adélaïde Labille-Guiard underlines the Museum's commitment in this area. Until recently Mantegna's *Adoration of the Magi* was the Museum's only work representing the Italian High Renaissance; the purchase of Ercole de' Roberti's *Saint Jerome in the Wilderness*, Correggio's *Head of Christ*, Giulio Romano's *Holy Family*, Fra Bartolommeo's *Rest on the Flight into Egypt with Saint John the Baptist*, and two panels by Domenico Beccafumi has helped to fill this major gap in the collection. In the nineteenth century the holdings of Géricault, Millet, Degas, Monet, and Cézanne have also continued to grow. We have had the opportunity further to enrich existing works in the Museum by acquiring two narrative paintings by Rembrandt, both old friends: *The Abduction of Europa* had been

pursued by Burton Fredericksen, and *Daniel and Cyrus before the Idol Bel* by Myron Laskin.

The paintings collection begun by J. Paul Getty in the 1930s was not conceived for a public museum. Only during the last forty years were acquisitions made with the public in mind. Mr. Getty's idiosyncratic approach to acquiring paintings has given the collection a particular character. But Getty's individualism was, perhaps, as much a legacy to the Museum as was his endowment. Today the paintings collection represents the distinctive visions of a succession of directors and curators. What may unite them in the public imagination is the perception of a string of classic Getty purchases—famous paintings, by famous artists, for very high prices—of which Van Gogh's *Irises* remains the best known. The collection is, however, deeper and more interesting than the cluster of now-popular Italian Renaissance and late nineteenth-century French paintings. It has always been the Museum's goal to acquire paintings of the most outstanding quality, and these are often neither the most expensive nor "one of the 100 greatest masterpieces" dreamed of by the Museum's founder. It is hoped that the richness and variety of the more surprising purchases will speak to a more diverse audience and touch people less steeped in the present critical canon of masterpieces. The endeavor to assemble a collection representing the best examples of Western European painting up to the twentieth century is ongoing.

David Jaffé
CURATOR

Notes

1 A group of Italian paintings was sold at Christie's New York, May 21, 1992, and many nineteenth-century paintings were sold at Sotheby's London, November 21, 22, 28, and 29, 1989; at Christie's New York, June 5, 1980; and Christie's London, June 30, 1980.

2 For this reason the prices of paintings acquired by Mr. Getty are included. Prices for works of art acquired by the J. Paul Getty Museum are not included because they are in some cases confidential. Mr. Getty's example illustrates how knowledge of price, whether factual or speculative, affects the viewer's perception of a work of art.

3 Fowles, letter dated August 4, 1939, to his New York colleague Bert Boggis, Duveen Archives, Getty Research Institute. Upon his return from California, Fowles also reported on April 15, 1954, that "Getty is leaving all his money to a foundation for the promotion of art, in other words, for a museum." This intention became known to Museum staff only after Getty's death.

4 July 5, 1950, Fowles to Mr. Carlhian, Duveen Archives, Getty Research Institute. He was pleased Getty visited without Leon Lacroix, who, along with Gerald Brockhurst, was an early advisor.

5 Parke-Bernet Galleries, Walters, April 30–May 3, 1941, lot 1211, Bouguereau; lot 986, Romney. The Romney cost $5,000; Walters had paid $50,000 for it in the Gary Sale in April 1928, as Fowles informed Getty in his letter of May 6, 1941.

6 Duveen's had previously sold Rembrandt's *Aristotle Contemplating the Bust of Homer* for $750,000 in 1935; it was later bought by the Metropolitan Museum of Art for $2,300,000 at Sotheby's on November 15, 1961 (lot 7).

7 In his book *The Joys of Collecting* (New York, 1965), p. 14, Getty refers to this purchase of a group of paintings as a "digression." It might be argued that Sickert's *French Kitchen*, acquired by Getty in 1938 for $113, further indicates a taste for late Impressionistic painting.

8 Letter dated November 21, 1942, Duveen Archives, Getty Research Institute. Bert Boggs wrote to Getty on May 22, 1941, about the sale of several of the Sorollas to French and Co.; Duveen Archives. Getty's ledgers record the sale of three for $3,500. In 1946 Getty also made a profit on the sale of a Renoir acquired in 1939.

9 Letter to the director, Roland McKinney, February 3, 1944.

10 April 15, 1954, Fowles's report on his visit to Malibu. Curiously Fowles was aware that Getty was going to leave all his money for an art museum, insider information that never leaked to the Museum staff. Also, according to Fowles, the Museum's first director, Dr. W. R. Valentiner (from 1953 to 1954), implied a particular interest in the case of a Rubens portrait of a woman: "I asked 150 for the Doria portrait but Valentiner said that Getty would naturally prefer a nude woman."

11 Rubens's *Adoration of the Magi* is now on the high altar of the chapel of King's College, Cambridge, England.

12 Rubens remains a difficult artist to quantify, but now most scholars would agree

that all the "Rubens" paintings acquired
by Getty (including *Four Studies of a
Male Head*, acquired in 1971, and *David
Meeting Abigail*, in 1973) are, at best,
workshop products.

13 Krautheimer Archives, Getty Research
Institute.

14 December 12, 1952, Ethel Le Vane Archive,
Getty Research Institute. Le Vane was
Getty's companion and the coauthor of
his catalogue.

15 Getty wrote to Berenson in the fall of 1952
with his ambivalent acknowledgment of
Berenson's accurate judgment.

16 On February 19, 1956, Getty wrote to
Berenson, "I did buy the Gutekunst Titian,
emboldened by your good opinion of it."
On September 21, 1954, Getty told Berenson
" . . . about the three paintings. As soon
as I received your letter I bought them."
These were the paintings (including the
Bartolomeo Veneto) that Getty acquired
from Bellini in Florence and offered to
the Los Angeles County Museum of Art.

17 Getty acquired the three Impressionists
at a Paris auction in 1956. Degas's *Three
Dancers in Rose* cost $21,602 and was sold
in 1989, Renoir's *Village of Essoyes* cost
$5,650 and was sold in 1980, and Monet's
Cliffs of Pourville cost him $4,121 and was
sold in 1989. In 1959 he acquired a Gauguin
for $26,750 and a Pissarro for $23,918. All
but the Pissarro are illustrated in J. Paul
Getty, *The Joys of Collecting* (New York,
1965), pp. 132–36.

Catalogue

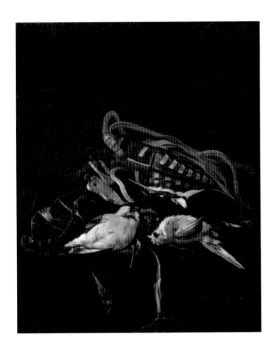

WILLEM VAN AELST
Dutch, 1627–after 1687
*Still Life with Dead Birds and
Game Bag*
1674
Oil on canvas
Signed upper right:
"Guill.[mo]. van Aelst 1674"
45 × 37 cm (17¾ × 14½ in.)
85.PA.236

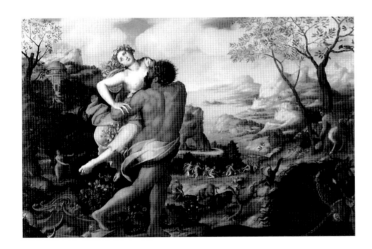

ALESSANDRO ALLORI
Italian, 1535–1607
The Abduction of Proserpine
1570
Oil on panel
Inscribed below right foot of
Pluto: "ALEXANDER ALORIUS
ANGELI BRONZINI ALUMNUS
FACIEBAT A D MDLXX"
228.5 × 348 cm (90 × 137 in.)
73.PB.73

LAWRENCE ALMA-TADEMA
English, 1836–1912
Spring
1894
Oil on canvas
Signed lower left:
"L. Alma Tadema op CCCXXVI"
178.4 × 80 cm (70¼ × 31½ in.)
72.PA.3

FRA ANGELICO (GUIDO DI
PIETRO, FRA GIOVANNI DA
FIESOLE)
Italian, ca. 1395/1400–1455
Saint Francis and a Bishop Saint
Late 1420s
Tempera and gold leaf on panel
52 × 23 cm (20¾ × 9⅛ in.)
92.PB.111.1

FRA ANGELICO (GUIDO DI
PIETRO, FRA GIOVANNI DA
FIESOLE)
Italian, ca. 1395/1400–1455
*Saint John the Baptist and Saint
Dominic*
Late 1420s
Tempera and gold leaf on panel
52 × 21 cm (20¾ × 8¼ in.)
92.PB.111.2

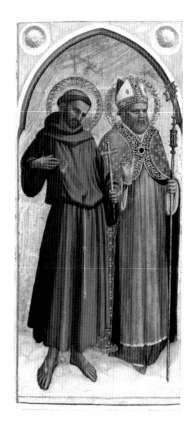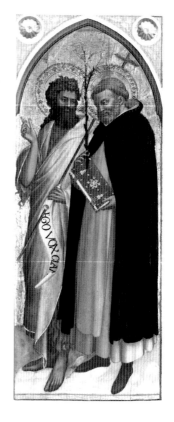

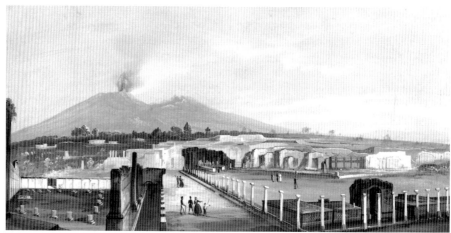

ANONYMOUS, 19TH CENTURY
Panorama of Pompeii
First half, 19th century
Tempera on paper
Inscribed lower left: "Panorama
di Pompei"; lower right: "Largo
Capella a Chiaja No. 5 (?)"
46.3 × 88.4 cm (18¼ × 34¾ in.)
73.PC.144
(Gift of Mr. and Mrs Benjamin
Kogut)

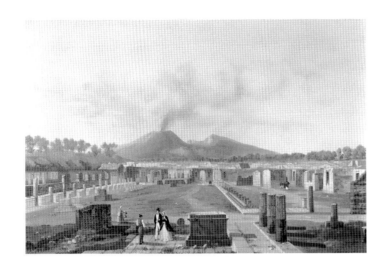

ANONYMOUS, 19TH CENTURY
Excavation at Pompeii
First half, 19th century
Tempera on paper
Inscribed lower right: "Tempio
di Giove/Lapira (?) V"
50.8 × 71.2 cm (20 × 28 1/16 in.)
73.PC.145
(Gift of Mr. and Mrs. Benjamin
Kogut)

ANONYMOUS, 19TH CENTURY
Ruins of Pompeii
First half, 19th century
Tempera on paper
19.6 × 28.8 cm (7 3/4 × 11 3/8 in.)
73.PC.146
(Gift of Mr. and Mrs. Benjamin
Kogut)

ANONYMOUS, 19TH CENTURY
Ruins of Paestum
First half, 19th century
Tempera on paper
19.8 × 29.5 cm (7 3/4 × 11 5/8 in.)
73.PC.147
(Gift of Mr. and Mrs. Benjamin
Kogut)

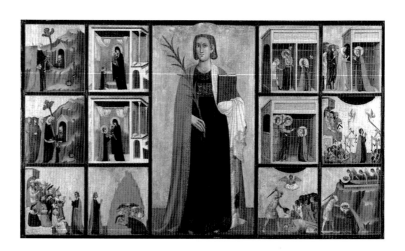

DONATO AND GREGORIO D'AREZZO
Italian, active 1315–ca. 1340
Saint Catherine of Alexandria and Twelve Scenes from Her Life
ca. 1330
Tempera and gold leaf on panel
100 × 170 cm (39⅜ × 67 in.)
73.PB.69

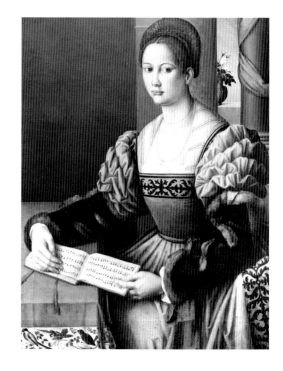

JACQUES-ANDRÉ-JOSEPH AVED
French, 1702–1766
Marc de Villiers, Secrétaire du Roi
1747
Oil on canvas
Signed lower right on armchair:
"AVED 1747"
146.5 × 114.5 cm (57¾ × 45⅛ in.)
79.PA.70

ATTTRIBUTED TO BACCHIACCA
(FRANCESCO UBERTINI)
Italian, 1495–1557
Portrait of a Woman with a Book of Music
ca. 1540s
Oil on panel
103 × 80 cm (40½ × 31½ in.)
78.PB.227

JACOB ADRIAENSZ. BACKER
Dutch, 1608–1651
Portrait of a Woman
ca. 1650
Oil on canvas
95 × 75 cm (37 ½ × 29 ½ in.)
71.PA.18
(Gift of J. Paul Getty)

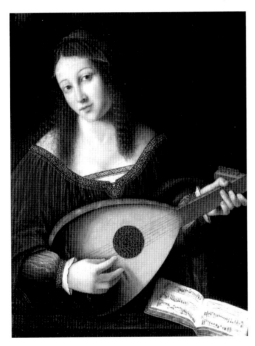

BARTOLOMEO VENETO AND WORKSHOP
Italian, active 1502–1555
Lady Playing a Lute
ca. 1530
Oil on panel
56.2 × 41.8 cm (22 ⅛ × 16 ⁵⁄₁₆ in.)
78.PB.221

FRA BARTOLOMMEO
(BACCIO DELLA PORTA)
Italian, 1472–1517
*The Rest on the Flight into Egypt
with Saint John the Baptist*
ca. 1509
Oil on panel
129.5 × 106.6 cm (51 × 42 in.)
96.PB.15

WILLEM BARTSIUS
Dutch, ca. 1612–after 1639(?)
Abraham Pleading with Sarah on Behalf of Hagar
1631
Oil on canvas
Signed lower right:
"W. Bartsius fet. / 1631"
121 × 89 cm (41¾ × 35 in.)
71.PA.70
(Gift of William Garred)

JACOPO BASSANO
(JACOPO DA PONTE)
Italian, ca. 1510/15–1592
Portrait of a Bearded Man
ca. 1550
Oil on canvas
61 × 53.2 cm (24 × 21 in.)
69.PA.25

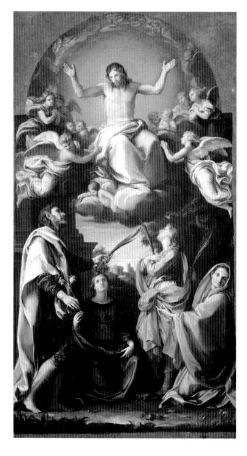

POMPEO BATONI
Italian, 1708–1787
Christ in Glory with Saints Celsus, Julian, Marcionilla, and Basilissa
1736–37
Oil on canvas
34 × 63 cm (13⅜ × 24⅞ in.)
69.PA.3

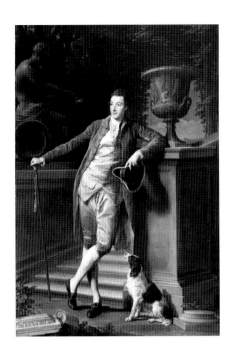

POMPEO BATONI
Italian, 1708–1787
John Talbot, Later 1st Earl Talbot
1773
Oil on canvas
Signed on pedestal lower right:
"P. BATONI PINXIT ROMAE ANNO
1773"
274.5 × 182 cm (108 × 71¾ in.)
78.PA.211

DOMENICO BECCAFUMI (DOMENICO
DI GIACOMO DI PACE)
Italian, 1484–1551
*Saint Catherine of Siena Receiving
the Stigmata*
ca. 1513–15
Oil and gold leaf on panel
28.6 × 41.3 cm (11¼ × 16¼ in.)
97.PB.25

DOMENICO BECCAFUMI (DOMENICO
DI GIACOMO DI PACE)
Italian, 1484–1551
*The Miraculous Communion
of Saint Catherine of Siena*
ca. 1513–15
Oil and gold leaf on panel
28.6 × 41.3 cm (11¼ × 16¼ in.)
97.PB.26

JAN ABRAHAMSZ. BERSTRAATEN
Dutch, 1622–ca. 1666
Winter Landscape
ca. 1655–65
Oil on panel
76.5 × 110 cm (30⅛ × 43¼ in.)
78.PB.70

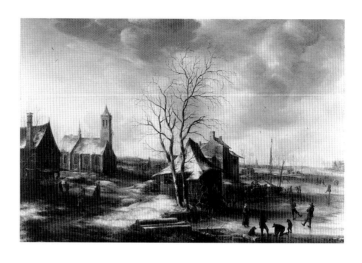

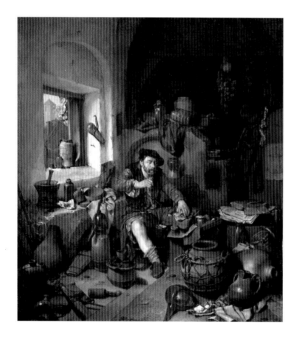

CORNELIS BEGA
Dutch, 1631/32–1664
The Alchemist
1663
Oil on panel
Signed on blue paper:
"A° 1663 C bega"
35.5 × 31.7 cm (14 × 12½ in.)
84.PB.56

BERNARDO BELLOTTO
Italian, 1721–1780
A View of the Grand Canal:
Santa Maria della Salute and
the Dogana from Campo Santa
Maria Zobenigo
ca. 1740
Oil on canvas
135.5 × 232.5 cm (53¼ × 91¼ in.)
91.PA.73

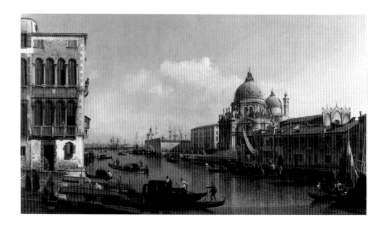

JOHANNES VAN DER BENT
Dutch, ca. 1650–1690
Landscape with Peasants
ca. 1670–90
Oil on canvas
92 × 77 cm (36¼ × 30⅞ in.)
70.PA.17
(Gift of J. Paul Getty)

NICOLAES BERCHEM
Dutch, 1620–1683
*Landscape with a Nymph and
a Satyr*
1647
Oil on panel
Signed at right edge:
"Berchem 164(7)"
68.6 × 58.4 cm (27 × 23 in.)
71.PB.33

NICOLAES BERCHEM
Dutch, 1620–1683
Landscape with Figures
ca. 1657
Oil on canvas
Signed lower right: "Berchem F."
139.7 × 174 cm (55 × 68½ in.)
86.PA.731

CHRISTOFFEL VAN DEN BERGHE

Dutch, active ca. 1617–after 1642

Still Life with Dead Birds

1624

Oil on canvas

Signed and dated on table:

"Cv berghe 1624"

72.4 × 100.3 cm (28 ½ × 39 ½ in.)

71.PA.34

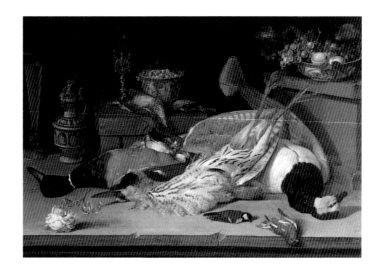

JOACHIM BEUCKELAER

Netherlandish, ca. 1533–ca. 1574

The Miraculous Draught of Fishes

1563

Oil on panel

Signed on runner of sled:

"JB 1563 Julia 6"

110.5 × 221 cm (43 ½ × 83 in.)

71.PB.59

BIAGIO D'ANTONIO

Italian, 1446–after 1508

The Story of Joseph

ca. 1485

Tempera and gold leaf on panel

66.6 × 149.3 cm (26 ¼ × 58 ¾ in.)

70.PB.41

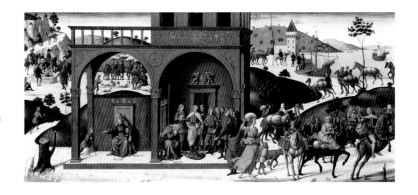

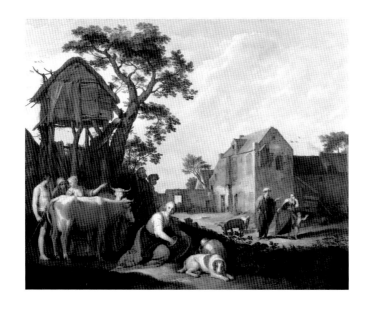

ABRAHAM BLOEMAERT AND
WORKSHOP
Dutch, 1566–1651
*The Expulsion of Hagar and
Ishmael*
1638
Oil on canvas
Signed lower left: "A.Blomert
16(3)8"
149.5 × 180 cm (57¾ × 71 in.)
69.PA.16

ROBERTO BOMPIANI
Italian, 1821–1908
A Roman Feast
ca. late 19th century
Oil on canvas
Signed lower left: "Rto Bompiani"
127 × 163.2 cm (50 × 64½ in.)
72.PA.4

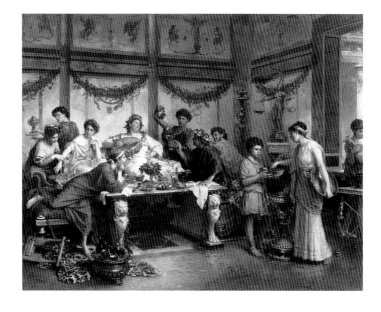

PIERRE BONNARD
French, 1867–1947
Landscape with Bathers
1906
Oil on canvas
Signed lower right: "Bonnard"
251.5 × 464.7 cm (99 × 183 in.)
69.PA.33

GERARD TER BORCH
Dutch, 1617–1681
A Maid Milking a Cow in a Barn
ca. 1652–54
Oil on panel
47.5 × 50.2 cm (18¾ × 19¾ in.)
83.PB.232

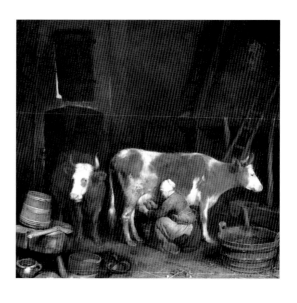

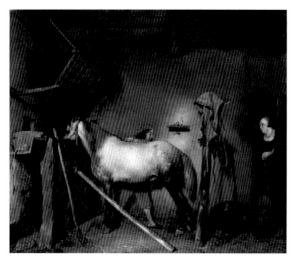

GERARD TER BORCH
Dutch, 1617–1681
A Horse Stable
ca. 1652–54
Oil on panel
Inscribed on back of panel: "GTB"
45.3 × 53.5 cm (17¹³⁄₁₆ × 21¹⁄₁₆ in.)
86.PB.631

GERARD TER BORCH
Dutch, 1617–1681
The Music Lesson
ca. 1668
Oil on canvas
67.7 × 54.9 cm (26⅝ × 21⅝ in.)
97.PA.47

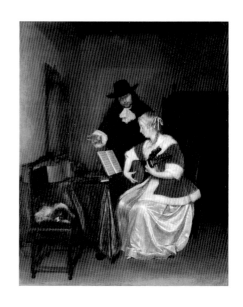

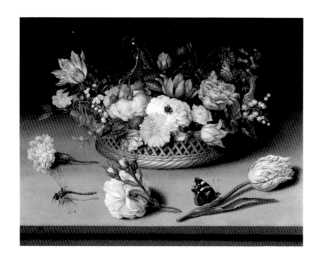

AMBROSIUS BOSSCHAERT THE ELDER
Dutch, 1573–1621
Flower Still Life
1614
Oil on copper
Signed lower left: ".AB.1614."
28.6 × 38.1 cm (11¼ × 15 in.)
83.PC.386

FRANÇOIS BOUCHER
French, 1703–1770
The Fountain of Love
1748
Oil on canvas
Signed lower center on the log:
"F.Boucher 1748"
294.5 × 337.7 cm (116 × 133 in.)
71.PA.37

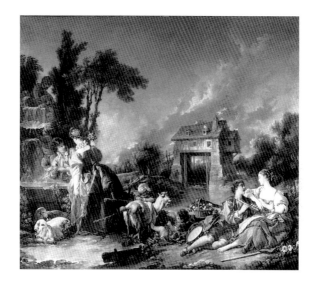

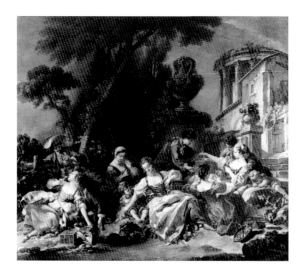

FRANÇOIS BOUCHER
French, 1703–1770
The Bird Catchers
1748
Oil on canvas
Signed lower right: "F.Boucher
1748"
294.5 × 337.7 cm (116 × 133 in.)
71.PA.38

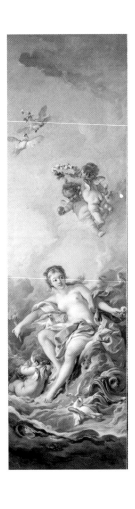

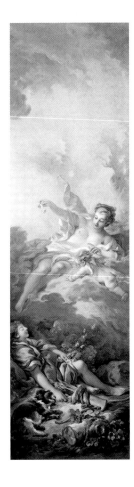

FRANÇOIS BOUCHER
French, 1703–1770
Venus on the Waves
1769
Oil on canvas
Signed lower right:
"f.Boucher, 1769"
265 × 86 cm (104⅓ × 33⅞ in.)
71.PA.54

FRANÇOIS BOUCHER
French, 1703–1770
Aurora and Cephalus
1769
Oil on canvas
Signed lower right: "f.Boucher, 1769"
265 × 86 cm (104⅓ × 33⅞ in.)
71.PA.55

WORKSHOP OF FRANÇOIS BOUCHER
French, 1703–1770
Two Shepherdesses
ca. 1750s
Oil on canvas
125.5 × 89 cm (49½ × 35 in.)
71.PA.23

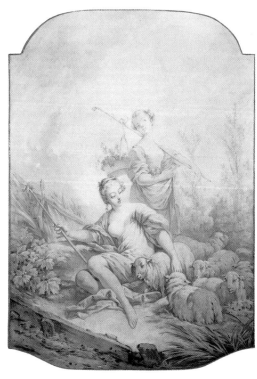

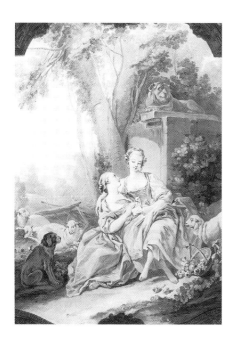

WORKSHOP OF FRANÇOIS BOUCHER
French, 1703–1770
The Letter
ca. 1750s
Oil on canvas
125.5 × 89 cm (49½ × 35 in.)
71.PA.24

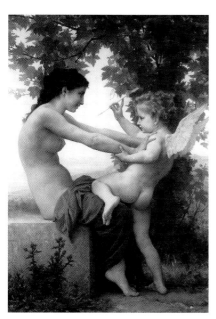

WILLIAM ADOLPHE BOUGUEREAU
French, 1825–1905
Young Girl Defending Herself against Eros
ca. 1880
Oil on canvas
Signed left center on block: "W.BOVGVEREAV"
79.5 × 55 cm (31¼ × 21⅝ in.)
70.PA.3
(Gift of J. Paul Getty)

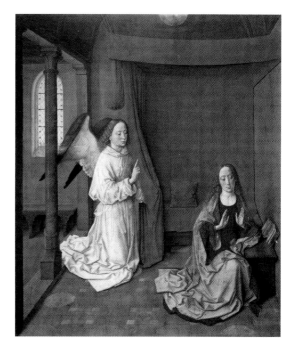

DIERIC BOUTS
Netherlandish, ca. 1415–1475
The Annunciation
ca. 1450–55
Distemper on linen
90 × 74.5 cm (35⁷⁄₁₆ × 29⅜ in.)
85.PA.24

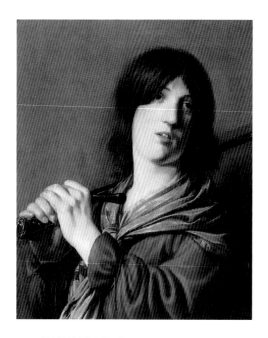

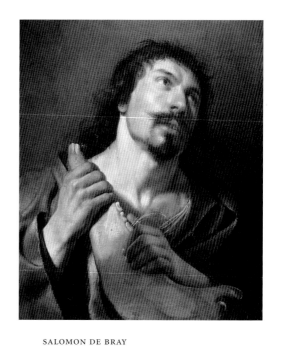

SALOMON DE BRAY
Dutch, 1597–1664
David with His Sword
1636
Oil on canvas
62 × 51 cm (24½ × 20 in.)
69.PA.22

SALOMON DE BRAY
Dutch, 1597–1664
Bust of Samson
1636
Oil on canvas
Signed on jawbone: "SDBray 1636"
62 × 51 cm (24½ × 20 in.)
69.PA.23

BARTHOLOMEUS BREENBERGH
Dutch, 1598–1657
*Moses and Aaron Changing the Rivers
of Egypt to Blood*
1631
Oil on panel
Signed lower left: "B.Breenbergh
f.A°.1631" with a "C" (?) below it
58 × 83 cm (22⅞ × 32¾ in.)
70.PB.14
(Gift of J. Paul Getty)

BARTHOLOMEUS BREENBERGH
Dutch, 1598–1657
The Stoning of Saint Stephen
1632
Oil on panel
Signed lower left: "B. Breenbergh
F. A° 1632"
67.5 × 92 cm (26⁹⁄₁₆ × 36¼ in.)
84.PB.639

GERALD L. BROCKHURST
English, 1890–1978
J. Paul Getty
1938
Oil on canvas
Signed lower right:
"G L Brockhurst/1938"
73.5 × 61 cm (29 × 24 in.)
67.PA.2
(Gift of J. Paul Getty)

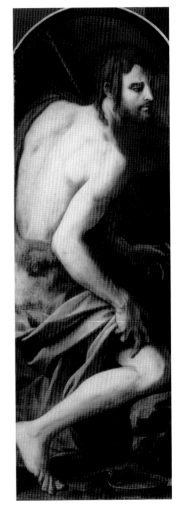

BRONZINO (AGNOLO DI
COSIMO)
Italian, 1503–1572
Saint John the Baptist
ca. 1542–45
Oil on panel
146 × 52 cm (57½ × 20½ in.)
73.PB.70

JAN BRUEGHEL THE ELDER
Flemish, 1568–1625
*Landscape with Saint John the
Baptist Preaching*
1598
Oil on copper
Signed lower right:
"Brueghel 1598"
27 × 37 cm (10½ × 14½ in.)
84.PC.71

JAN BRUEGHEL THE ELDER
Flemish, 1568–1625
*The Entry of the Animals into
Noah's Ark*
1613
Oil on panel
Signed lower right:
"BRUEGHEL FEC. 1613"
54.6 × 83.8 cm (21½ × 33 in.)
92.PB.82

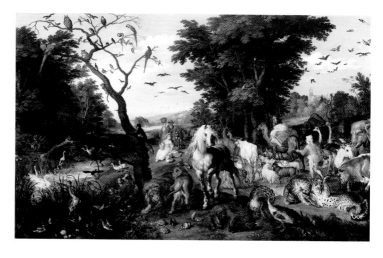

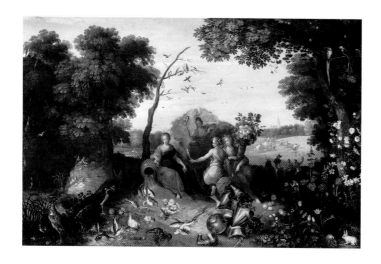

JAN BRUEGHEL THE YOUNGER,
WITH FIGURES BY FRANS
FRANCKEN II
Flemish, 1601–1678;
Flemish, 1581–1642
*Landscape with Allegories of
the Four Elements*
ca. 1630s
Oil on panel
52.5 × 81.5 cm (20¾ × 32 in.)
71.PB.28

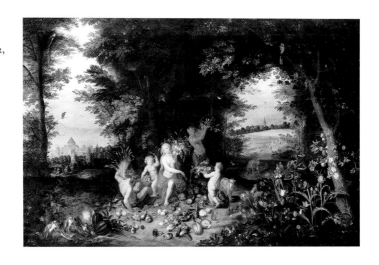

JAN BRUEGHEL THE YOUNGER,
WITH FIGURES BY HENDRIK
VAN BALEN
Flemish, 1601–1678;
Flemish, 1575–1632
Allegory of Earth
ca. 1630s
Oil on panel
52.5 × 81.5 cm (20¼ × 32 in.)
71.PB.29

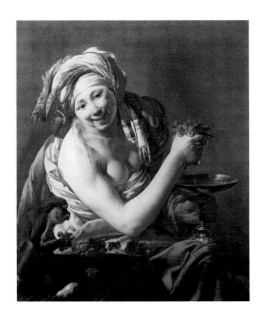

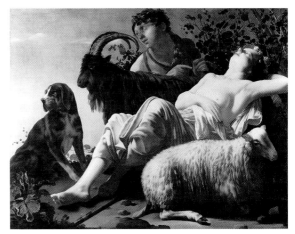

HENDRICK TER BRUGGHEN
Dutch, 1588–1629
Bacchante with an Ape
1627
Oil on canvas
Signed lower right:
"HTB rugghen fecit / 1627"
102.9 × 90.1 cm (40½ × 35½ in.)
84.PA.5

ATTRIBUTED TO HENDRICK TER
BRUGGHEN
Dutch, 1588–1629
*Episode from the Story of Granida
and Daifilo*
ca. 1625–29
Oil on canvas
121 × 157 cm (47⅝ × 61¾ in.)
72.PA.1

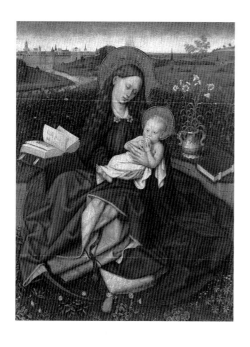

AFTER ROBERT CAMPIN

Netherlandish, ca. 1375–1444

The Madonna of Humility

ca. 1450–70

Oil on panel

48.5 × 37.8 cm (19⅛ × 14⅞ in.)

77.PB.28

CANALETTO

(GIOVANNI ANTONIO CANAL)

Italian, 1697–1768

*The Arch of Constantine with the
Colosseum in the Background*

ca. 1742–45

Oil on canvas

Signed at left on stone:

"Ant° Canaleto fe¹"

82 × 122 cm (32¼ × 48 in.)

70.PA.52

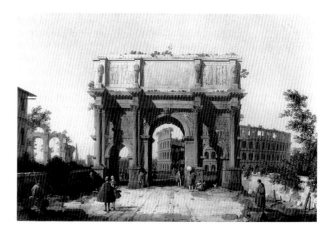

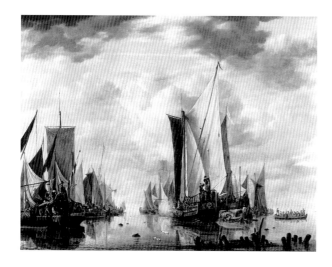

JAN VAN DE CAPPELLE

Dutch, 1626–1679

*Shipping in a Calm at Flushing with a
States General Yacht Firing a Salute*

1649

Oil on panel

Signed at lower right:

"J V. capeL 1649"

69.7 × 92.2 cm (27⅜ × 36¼ in.)

96.PB.7

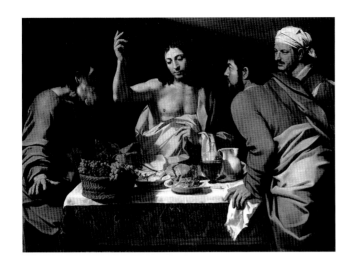

FOLLOWER OF CARAVAGGIO
Italian, 17th century
The Supper at Emmaus
17th century
Oil on canvas
139.6 × 194.3 cm (55 × 76½ in.)
72.PA.11

WORKSHOP OF LUDOVICO CARDI
(CALLED CIGOLI)
Italian, 1559–1613
The Penitent Magdalen
1598
Oil on canvas
Signed lower right: "LC / 1598"
150 × 115 cm (59 × 45¼ in.)
71.PA.71
(Gift of William P. Garred)

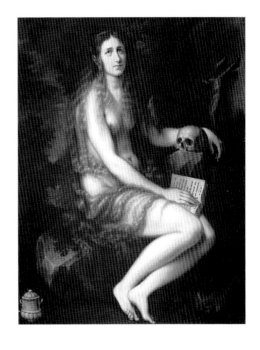

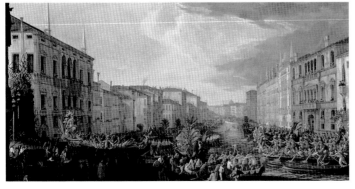

LUCA CARLEVARIJS
Italian, 1663–1730
*A Regatta on the Grand Canal
in Honor of Frederick IV,
King of Denmark*
1711
Oil on canvas
Signed lower left on stern of boat:
"MDCCXI L.C."
134.9 × 259.7 cm (53⅛ × 102¼ in.)
86.PA.599

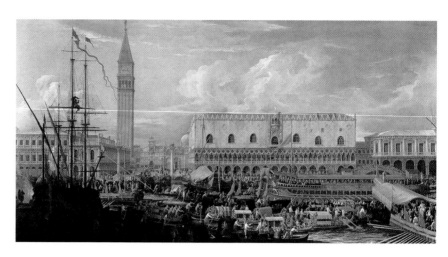

LUCA CARLEVARIJS
Italian, 1663–1730
*The Bucintoro Departing from
the Bacino di San Marco*
1710
Oil on canvas
Signed bottom right on boat:
"LC MDCC X"
134.7 × 259.3 cm (53 ¹/₁₆ × 102 ⅛ in.)
86.PA.600

ANTOINE CARON
French, 1521–1598/99
*Dionysius the Areopagite Converting
the Pagan Philosophers*
ca. 1570s
Oil on panel
93 × 73 cm (36 ½ × 28 ¾ in.)
85.PB.117

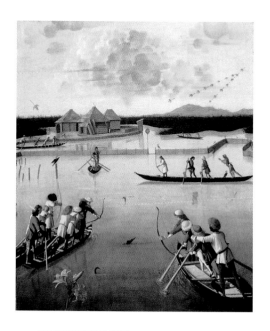

VITTORE CARPACCIO
Italian, ca. 1460/65 – 1525/26
Hunting on the Lagoon (recto)/
Letter Rack (verso)
ca. 1490 – 95
Oil on panel
75.4 × 63.8 cm (29¾ × 25⅛ in.)
79.PB.72

LODOVICO CARRACCI
Italian, 1555 – 1619
*Saint Sebastian Thrown into
the Cloaca Maxima*
1612
Oil on canvas
167 × 233 cm (65¾ × 91¾ in.)
72.PA.14

GIOVANNI BENEDETTO
CASTIGLIONE
Italian, 1609–1664
Arcadian Shepherds
ca. 1655
Oil on canvas
109.2 × 109.2 cm (43 × 43 in.)
72.PA.19

BERNARDO CAVALLINO
Italian, 1616–1656
*The Shade of Samuel Invoked
by Saul*
ca. 1650–56
Oil on copper
Signed lower left corner: "BC"
61 × 86.5 cm (24 × 34 in.)
83.PC.365

CENNI DI FRANCESCO DI SER CENNI
Italian, active 1369/70–1415
*Polyptych with the Coronation of
the Virgin and Saints*
ca. 1390s
Tempera and gold leaf on panel
355.8 × 233 cm (140 × 91¼ in.)
71.PB.31

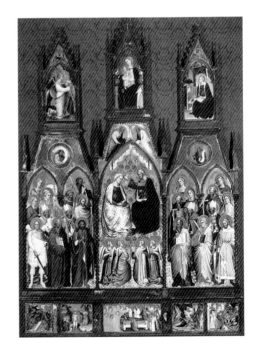

PAUL CÉZANNE
French, 1839–1906
Anthony Valabrègue
ca. 1869–71
Oil on canvas
60 × 50 cm (23⅝ × 19¼ in.)
85.PA.45

PAUL CÉZANNE
French, 1839–1906
The Eternal Feminine
ca. 1877
Oil on canvas
43.2 × 53.3 cm (17 × 20⅞ in.)
87.PA.79

PAUL CÉZANNE
French, 1839–1906
Still Life with Apples
ca. 1893–94
Oil on canvas
65.5 × 81.5 cm (25¼ × 32⅛ in.)
96.PA.8

PHILIPPE DE CHAMPAIGNE
French, 1602–1674
Antoine Singlin
ca. 1646
Oil on canvas
Inscribed and signed lower edge:
"Messire Anthoine Singlin
décédé le 17 avril 1664.
Ph. Champaigne"
79 × 65 cm (31⅛ × 25⅝ in.)
87.PA.3

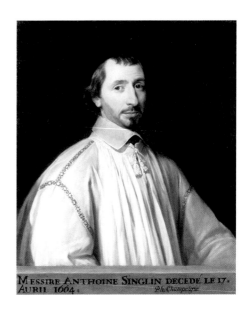

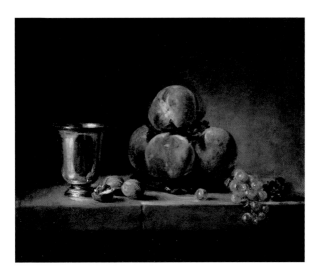

JEAN-BAPTISTE SIMÉON CHARDIN
French, 1699–1779
Still Life
By 1760
Oil on canvas
Signed left center: "Chardin"
37.8 × 46.7 cm (14⅞ × 18⅜ in.)
86.PA.544

ATTRIBUTED TO PIETER CLAESZ.
Dutch, 1597/98–1661
Vanitas Still Life
Mid-1630s
Oil on panel
Signed lower book cover: "PC 1634"
54 × 71.5 cm (21¼ × 28⅛ in.)
70.PB.37

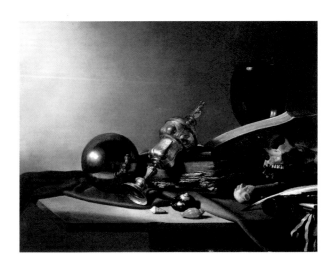

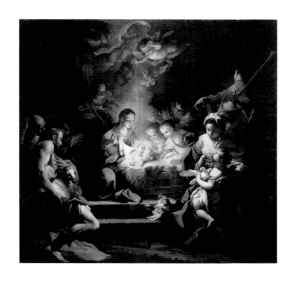

SEBASTIANO CONCA
Italian, 1680–1764
The Adoration of the Shepherds
1720
Oil on canvas
243.7 × 264 cm (96 × 104 in.)
78.PA.232

ANDRIES DE CONINCK
Dutch, died 1659
Still Life with Lobster and Fruit
Mid-1640s
Oil on canvas
Signed on window sill:
"A. De CONINCK fe."
136.5 × 170 cm (53¾ × 67 in.)
78.PA.218

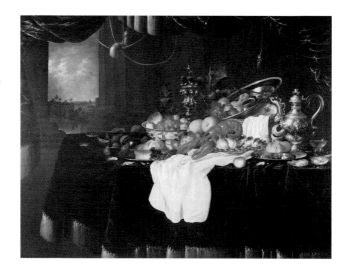

JEAN-BAPTISTE-CAMILLE COROT
French, 1796–1875
Italian Landscape
ca. 1835
Oil on canvas
Signed lower left: "C[o]rot. [18]39"
63.5 × 101.4 cm (25 × 39⅞ in.)
84.PA.78

JEAN-BAPTISTE-CAMILLE COROT
French, 1796–1875
Landscape with Lake and Boatman
1839
Oil on canvas
Signed lower left: "Corot. 1839"
65.2 × 102.2 cm (24⅝ × 40½ in.)
84.PA.79

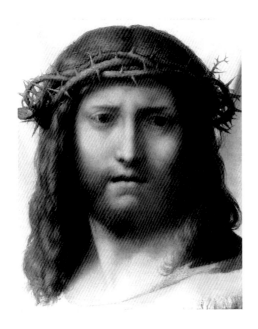

CORREGGIO (ANTONIO ALLEGRI)
Italian, ca. 1489/94–1534
Head of Christ
ca. 1525–30
Oil on panel
28.6 × 23 cm (11¼ × 9⅛ in.)
94.PB.74

PLACIDO COSTANZI
Italian, ca. 1690–1759
The Immaculate Conception
ca. 1730
Oil on canvas
65.4 × 81.3 cm (25¼ × 32 in.)
70.PA.42

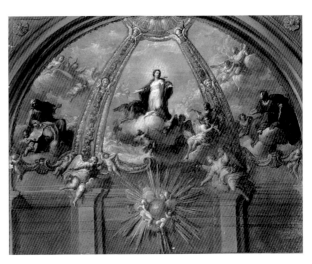

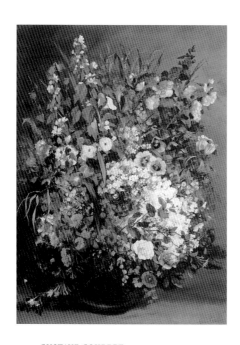

GUSTAVE COURBET
French, 1819–1877
Bouquet of Flowers in a Vase
1862
Oil on canvas
Signed lower right:
"'62 Gustave Courbet"
100.5 × 73 cm (39 ½ × 28 ¾ in.)
85.PA.168

CHARLES-ANTOINE COYPEL
French, 1694–1752
Self-Portrait
1734
Pastel on paper
Inscribed lower right: "Charles
Coypel s'est peint / lui-même pour
Philippe / Coypel son frère et son /
ami qui plus est / 1734
98 × 80 cm (38 ⅝ × 31 ½ in.)
97.PC.19

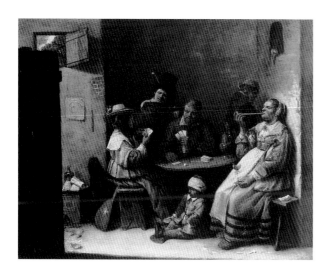

JOSSE VAN CRAESBEECK
Flemish, ca. 1605/08 – before 1662
Card Players
ca. 1645
Oil on panel
Signed lower right: "IVC"
30 × 38 cm (11 ¾ × 15 in.)
70.PB.18
(Gift of J. Paul Getty)

GIUSEPPE MARIA CRESPI
Italian, 1665–1747
*The Blessed Bernard Tolomei
Interceding for the Cessation
of the Plague in Siena*
ca. 1735
Oil on copper
42.7 × 66.6 cm (16¹³⁄₁₆ × 26¼ in.)
86.PC.463

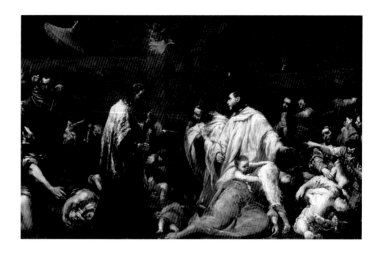

ANTHONIE JANSZ. VAN DER CROOS
Dutch, 1606/07–after 1661
Landscape with a View of Rhenen
1656
Oil on canvas
Signed: "A V Croos F 1656"
116 × 195.5 cm (45¾ × 77 in.)
78.PA.203

AELBERT CUYP
Dutch, 1620–1691
A View of the Maas at Dordrecht
ca. 1645/46
Oil on panel
Signed lower left: "A. Cuyp"
50 × 107.3 cm (19¾ × 42¼ in.)
83.PB.272

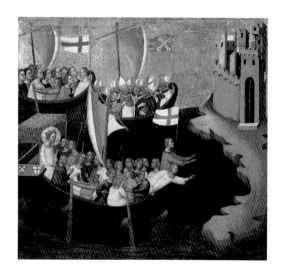

RICHARD DADD
British, 1817–1886
Mercy: David Spareth Saul's Life
1854
Oil on canvas
Signed top left: "RICHARD. DADD.
1854"
68.6 × 55.9 cm (27 × 22 in.)
87.PA.32

BERNARDO DADDI
Italian, ca. 1280–1348
*The Arrival of Saint Ursula
at Cologne*
ca. 1330
Tempera and gold leaf on panel
60 × 63 cm (23⅝ × 24¼ in.)
70.PB.53

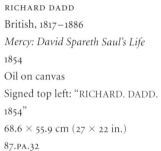

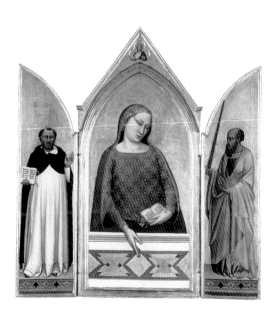

BERNARDO DADDI
Italian, ca. 1280–1348
*The Virgin Mary with Saints Thomas
Aquinas and Paul*
ca. 1330
Tempera and gold leaf on panel
Central panel: 120.7 × 55.9 cm
(47½ × 22 in.)
Left panel: 105.5 × 28 cm
(41½ × 11 in.)
Right panel: 105.5 × 27.6 cm
(41½ × 10⅞ in.)
93.PB.16

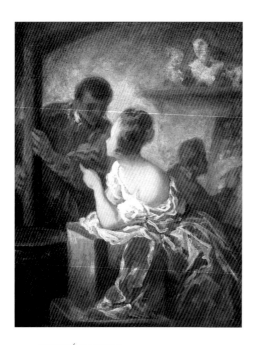

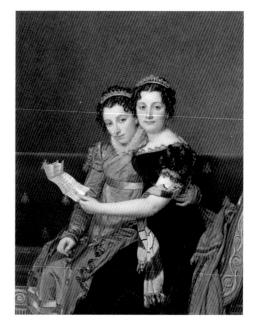

HONORÉ DAUMIER
French, 1808–1879
The Studio
ca. 1870
Oil on canvas
31 × 25 cm (12¼ × 9⅞ in.)
85.PA.514

JACQUES-LOUIS DAVID
French, 1748–1825
*The Sisters Zenaïde and Charlotte
Bonaparte*
1821
Oil on canvas
Signed lower right:
"L. David. / Brux. 1821"
129.5 × 100 cm (51 × 39⅛ in.)
86.PA.740

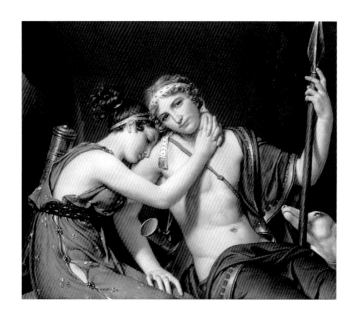

JACQUES-LOUIS DAVID
French, 1748–1825
*The Farewell of Telemachus
and Eucharis*
1818
Oil on canvas
Signed on quiver: "DAVID"; dated on
horn: "Brux 1818"
87.2 × 103 cm (34½ × 40½ in.)
87.PA.27

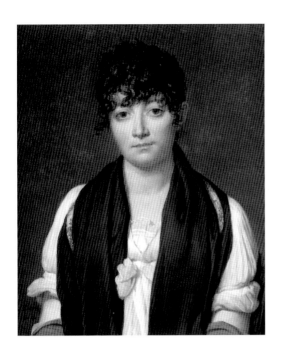

JACQUES-LOUIS DAVID
French, 1748-1825
Suzanne Le Peletier de Saint-Fargeau
1804
Oil on canvas
Signed lower left: "j.L David 1804"
23¾ × 19½ in. (60.5 × 49.5 cm)
97.PA.36

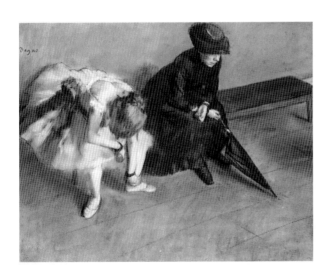

EDGAR DEGAS
French, 1834–1917
Waiting
ca. 1882
Pastel on paper
Signed upper left: "Degas"
48.2 × 61 cm (19 × 24 in.)
83.GG.219
(Owned jointly with the Norton Simon
Art Foundation)

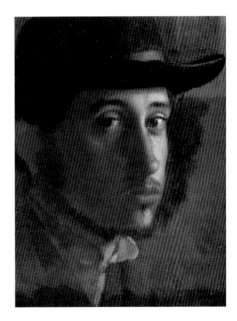

EDGAR DEGAS
French, 1834–1917
Self-Portrait
ca. 1857–58
Oil on paper, laid down on canvas
20.6 × 15.9 cm (8⅛ × 6¼ in.)
95.GG.43

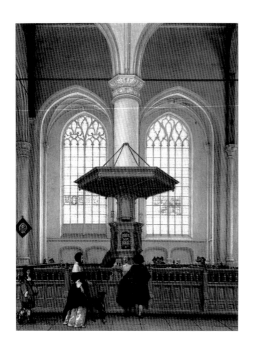

ANTHONIE DELORME, WITH
FIGURES ATTRIBUTED TO
LUDOLF DE JONGH
Dutch, ca. 1610–1679;
Dutch, 1616–1679
*Interior of the Laurenskerk at
Rotterdam*
1662
Oil on canvas
Signed lower left: "A.DE.LORME /
1662."
62.5 × 46.5 cm (24⅝ × 18¼ in.)
78.PA.69

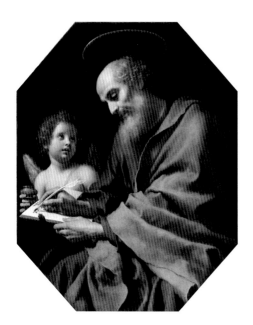

CARLO DOLCI
Italian, 1616–1687
Saint Matthew Writing His Gospel
ca. 1670s
Oil on canvas
136.5 × 113 cm (53¾ × 44½ in.)
69.PA.29

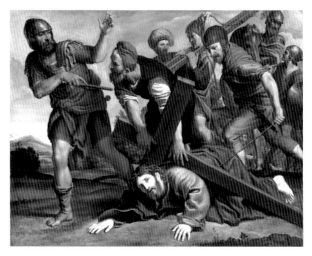

DOMENICHINO (DOMENICO ZAMPIERI)
Italian, 1581–1641
The Way to Calvary
ca. 1610
Oil on copper
53.7 × 68.3 cm (21⅛ × 26⅝ in.)
83.PC.373

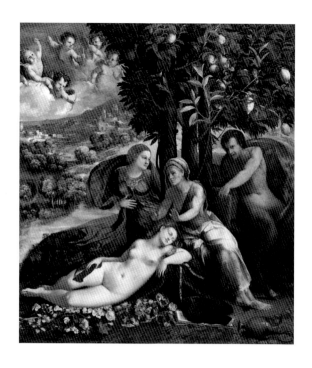

DOSSO DOSSI (GIOVANNI DI
NICCOLÒ DE LUTERO)
Italian, ca. 1490–1542
Mythological Scene
ca. 1524
Oil on canvas
163.8 × 145.4 cm (64½ × 57¼ in.)
83.PA.15

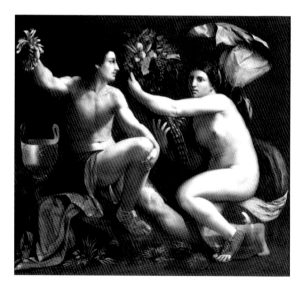

DOSSO DOSSI (GIOVANNI DI
NICCOLÒ DE LUTERO)
Italian, ca. 1490–1542
An Allegory of Fortune
ca. 1530
Oil on canvas
178 × 216.5 cm (70½ × 85½ in.)
89.PA.32

CIRCLE OF DOSSO DOSSI
(GIOVANNI DI NICCOLÒ DE LUTERO)
Italian, ca. 1490-1542
Laura Pisani
ca. 1525
Oil on canvas
91.5 × 80 cm (36 × 31½ in.)
78.PA.226

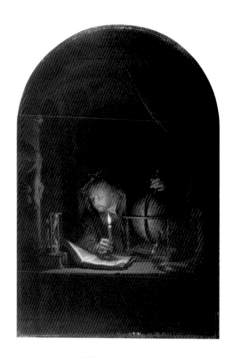

GERRIT DOU
Dutch, 1613–1675
*Prince Rupert of the Palatinate
and His Tutor in Historical Dress*
ca. 1631
Oil on canvas
102.9 × 88.7 cm (40½ × 34¼ in.)
84.PA.570

GERRIT DOU
Dutch, 1613–1675
Astronomer by Candlelight
Late 1650s
Oil on panel
Signed lower left on book:
"GDov"
32 × 21.3 cm (12⅝ × 8⅜ in.)
86.PB.732

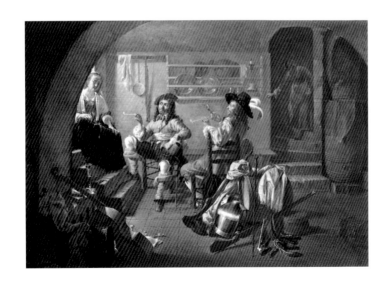

JACOB DUCK
Dutch, ca. 1600–1667
Interior with Soldiers and Women
ca. 1650
Oil on panel
Signed on bottom of overturned
barrel lower right: "JADuck"
42 × 61 cm (16½ × 24 in.)
70.PB.19
(Gift of J. Paul Getty)

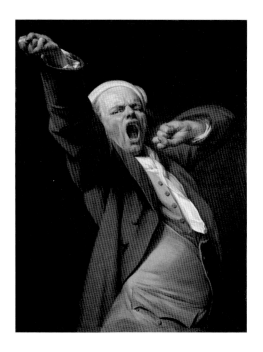

JOSEPH DUCREUX
French, 1735–1802
Self-Portrait, Yawning
By 1783
Oil on canvas
116 × 90 cm (45 × 35 in.)
71.PA.56

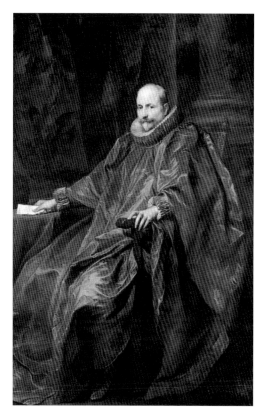

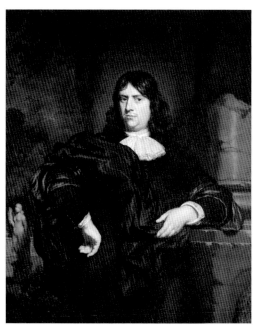

KAREL DUJARDIN
Dutch, ca. 1626–1678
Portrait of a Gentleman in Black
Late 1660s
Oil on canvas
128 × 102 cm (50⅜ × 40⅛ in.)
76.PA.40
(Gift of Peter and Iselin Moller)

ANTHONY VAN DYCK
Flemish, 1599–1641
Agostino Pallavicini
ca. 1621
Oil on canvas
Signed on right near back of
chair: "Antus Van Dyck fecit"
216 × 141 cm (85⅛ × 55½ in.)
68.PA.2

ANTHONY VAN DYCK
Flemish, 1599–1641
*Saint Sebastian Tended by
an Angel*
ca. 1630–32
Oil on panel
40.5 × 30.5 cm (16 × 12 in.)
85.PB.31

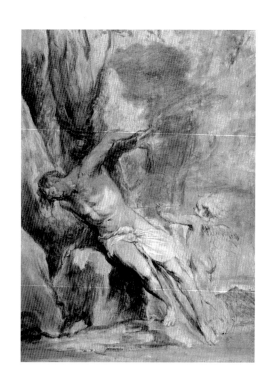

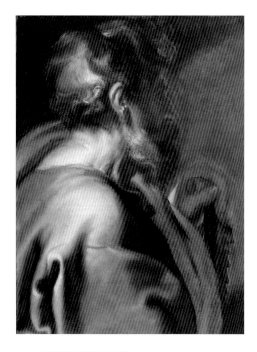

ANTHONY VAN DYCK
Flemish, 1599–1641
The Apostle Simon
ca. 1618
Oil on panel
64 × 48.2 cm (25³⁄₁₆ × 19 in.)
85.PB.99

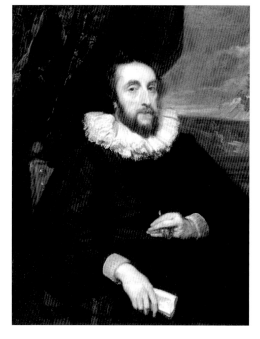

ANTHONY VAN DYCK
Flemish, 1599–1641
*Thomas Howard, 2nd Earl of
Arundel*
ca. 1620–21
Oil on canvas
102.8 × 79.4 cm (40½ × 31¼ in.)
86.PA.532

GERBRAND VAN DEN EECKHOUT
Dutch, 1621–1674
Hagar Weeping
Early 1640s
Oil on canvas
Signed on bottom of water jug:
"G Eeckhout"
76 × 68.5 cm (30 × 27 in.)
72.PA.22
(Gift of Martin J. Zimet)

WILHELM SCHUBERT VAN
EHRENBERG, WITH ANIMALS BY
CARL BORROMÄUS ANDREAS
RUTHART
Flemish, 1630–ca. 1676;
German, 1630–1703
Ulysses at the Palace of Circe
1667
Oil on canvas
Signed on placard between
pilasters above Ulysses's head:
"W.S. van / Ehrenberg, fec. / 1667"
88.5 × 121.5 cm (34⅞ × 47⅞ in.)
71.PA.20
(Gift of Mr. and Mrs. Thomas Brant)

ENGLISH, LATE 17TH CENTURY
James Hay, 1st Earl of Carlisle
ca. 1660s
Oil on canvas
Inscribed lower left: "Earl
of Carlisle"
218.4 × 132.1 cm (86 × 52 in.)
76.PA.41
(Gift of Peter and Iselin Moller)

JAMES ENSOR
Belgian, 1860–1949
Christ's Entry into Brussels in 1889
1888
Oil on canvas
Signed right center:
"J. ENSOR / 1888"
252.5 × 430.5 cm (99½ × 169½ in.)
87.PA.96

ERCOLE DE' ROBERTI
ca. 1450–1496
Saint Jerome in the Wilderness
ca. 1470
Tempera on panel
34 × 22 cm (13⅜ × 8⅝ in.)
96.PB.14

ATTRIBUTED TO CESAR VAN
EVERDINGEN
Dutch, ca. 1617–1678
Vertumnus and Pomona
ca. 1650
Oil on canvas
104 × 140 cm (41 × 55⅛ in.)
75.PA.64

FRANÇOIS-XAVIER FABRE
French, 1766–1837
Marie-Louise de Joubert,
née Poulletier de Perigny
1787
Oil on canvas
78 × 61 cm (30¾ × 24 in.)
79.PA.60.2

FRANÇOIS-XAVIER FABRE
French, 1766–1837
Laurent-Nicolas de Joubert
1787
Oil on canvas
78 × 61 cm (30¾ × 24 in.)
79.PA.60.1

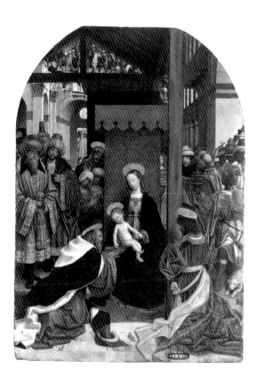

DEFENDENTE FERRARI
Italian, active ca. 1500–1535
The Adoration of the Magi
ca. 1520
Oil on panel
262 × 186 cm (103¼ × 73¼ in.)
74.PB.31

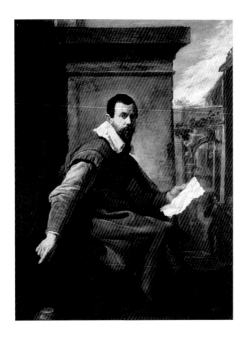

DOMENICO FETTI
Italian, ca. 1589–1623
*Portrait of a Man with a Sheet
of Music*
ca. 1620
Oil on canvas
173 × 130 cm (68 × 51⅛ in.)
93.PA.17

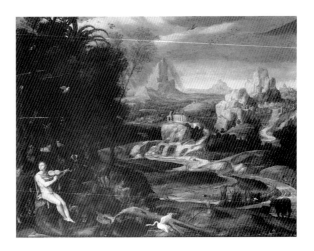

FLEMISH, 16TH CENTURY
Landscape with Orpheus
ca. 1570s
Oil on panel
35.5 × 46 cm (14 × 18 in.)
71.PB.64

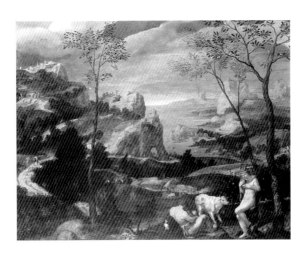

FLEMISH, 16TH CENTURY
Landscape with Mercury and Argus
ca. 1570s
Oil on panel
35.5 × 46 cm (14 × 18 in.)
71.PB.65

FLEMISH, 17TH CENTURY
Putti at a Forge
Mid-seventeenth century
Oil on canvas
47 × 63 cm (17½ × 25½ in.)
76.PA.46
(Gift of William P. Garred)

FLEMISH, ANTWERP SCHOOL,
16TH CENTURY
The Madonna and Child
ca. 1530–40
Oil on panel
57.7 × 44.7 cm (22¼ × 17⅝ in.)
69.PB.10

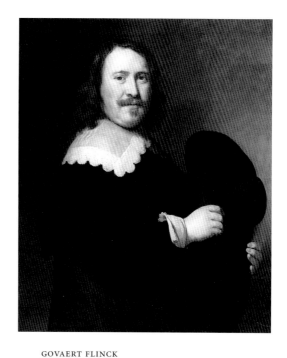

GOVAERT FLINCK
Dutch, 1615–1660
Portrait of a Man
1641
Oil on panel
Signed lower right: "G.Flinck 1641"
91.5 × 73.5 cm (36 × 29 in.)
71.PB.36

LUCA FORTE
Italian, ca. 1610/15–ca. 1670
Still Life with Grapes and Other Fruit
ca. 1630s
Oil on copper
Signed lower left: "Luca Forte"
31.4 × 26 cm (12⅜ × 10¼ in.)
86.PC.517

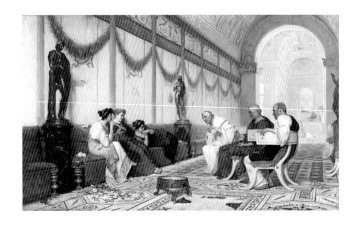

ETTORE FORTI
Italian, active end 19th century–
early 20th century
*Interior of Roman Building
with Figures*
ca. late 19th century
Oil on canvas
Signed lower right: "E.Forti / Roma"
66 × 106.5 cm (26 × 42 in.)
78.PA.72

FRANCESCO DI GIORGIO MARTINI
Italian, 1439–1501
The Triumph of Chastity
Mid-1460s
Tempera on panel
37 × 121 cm (14 ½ × 47 ⅝ in.)
57.PB.2

FRANCESCO DI GIORGIO MARTINI
Italian, 1439–1501
The Story of Paris
ca. 1460s
Tempera on panel
Central panel: 35 × 109 cm
(13 ¾ × 42 ⅞ in.)
End panels both: 34 × 17 cm
(13 ⅜ × 6 ⅝ in.)
70.PB.45

FRANS FRANCKEN II
Flemish, 1581–1642
The Idolatry of Solomon
1622
Oil on panel
Signed and dated on base of
pedestal: "f. franck in cf
A / 1622"
77.2 × 109.2 cm (30 ⅛ × 43 in.)
71.PB.42

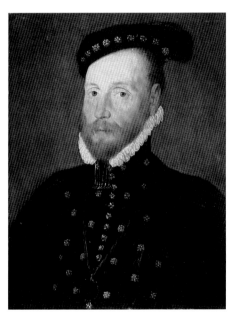

FRENCH, 16TH CENTURY
*Charles de Gondi, Seigneur
de la Tour*
Second half, 16th century
Oil on panel
51 × 38 cm (20 × 15 in.)
76.PB.42
(Gift of Peter and Iselin Moller)

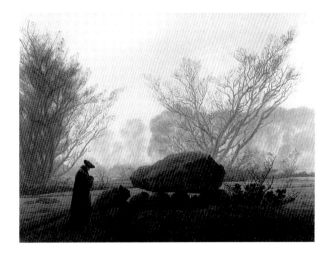

CASPAR DAVID FRIEDRICH
German, 1774–1840
A Walk at Dusk
ca. 1830–35
Oil on canvas
33.3 × 43.7 cm (13 ⅛ × 17 5/16 in.)
93.PA.14

PHILIP FRUYTIERS
Flemish, 1610–1666
David Teniers
1655
Oil on panel
Signed upper left:
"fruyters F. 1655"
35 × 24 cm (13¾ × 9½ in.)
73.PB.154
(Gift of Burton Fredericksen)

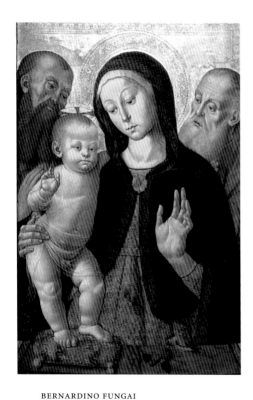

BERNARDINO FUNGAI
Italian, 1460–1516
*Madonna and Child with Two
Hermit Saints*
ca. 1480s
Tempera on panel
68.5 × 45.7 cm (27 × 18 in.)
69.PB.26

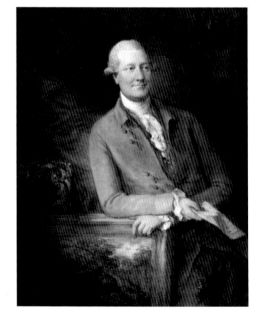

THOMAS GAINSBOROUGH
English, 1727–1788
James Christie
1778
Oil on canvas
126 × 102 cm (49⅝ × 40⅛ in.)
70.PA.16
(Gift of J. Paul Getty)

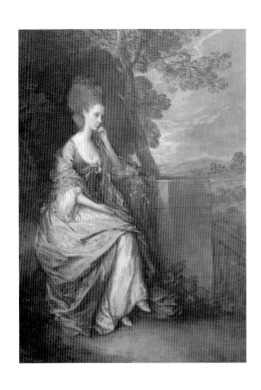

THOMAS GAINSBOROUGH
English, 1727–1788
Anne, Countess of Chesterfield
1777–78
Oil on canvas
219.7 × 156 cm (86½ × 61½ in.)
71.PA.8
(Gift of J. Paul Getty)

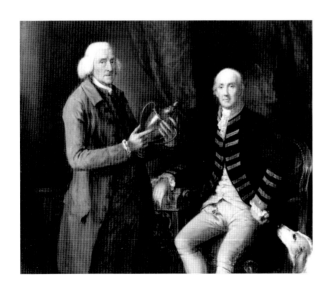

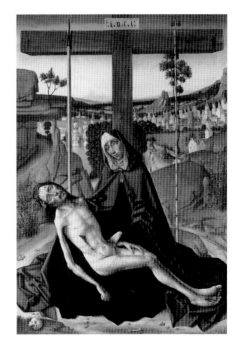

THOMAS GAINSBOROUGH
English, 1727–1788
William Anne Hollis, 4th Earl of Essex, Presenting a Cup to Thomas Clutterbuck of Watford
ca. 1784–85
Oil on canvas
148.5 × 174 cm (58½ × 68½ in.)
72.PA.2

CIRCLE OF FERNANDO GALLEGO
Spanish, ca. 1440/45–ca. 1507
The Pietà
ca. 1490–1500
Oil on panel
49.8 × 34.3 cm (19½ × 13½ in.)
85.PB.267

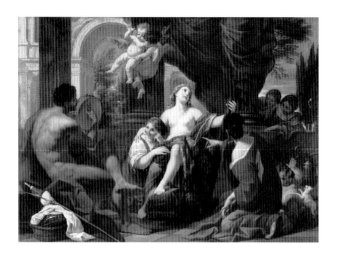

LUIGI GARZI
Italian, 1638–1721
Hercules and Omphale
ca. late 17th century
Oil on canvas
97.8 × 134.6 cm (38½ × 53 in.)
70.PA.35

GIOVANNI BATTISTA GAULLI
(CALLED BACICCIO)
Italian, 1639–1709
Saint Francesca Romana Giving Alms
ca. 1675
Oil on canvas
209.5 × 137.2 cm (82¾ × 54 in.)
70.PA.30

AERT DE GELDER
Dutch, 1645–1727
Ahilmelech Giving the Sword of Goliath to David
ca. 1680s
Oil on canvas
Signed on masonry, center: "A De Gelder fe"
90 × 132 cm (35½ × 52 in.)
78.PA.219

AERT DE GELDER
Dutch, 1645–1727
The Banquet of Ahasuerus
ca. 1680s
Oil on canvas
Signed upper right:
"A. de Gelder f."
115.6 × 142 cm (44 × 55 in.)
79.PA.71

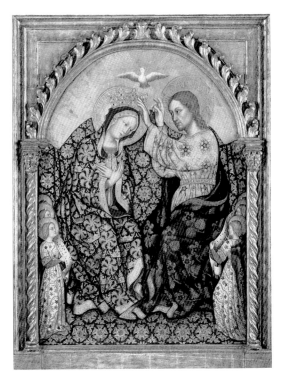

GENTILE DA FABRIANO
Italian, ca. 1370–1427
The Coronation of the Virgin
ca. 1420
Tempera and gold leaf on panel
87.5 × 64 cm (34½ × 25½ in.)
77.PB.92

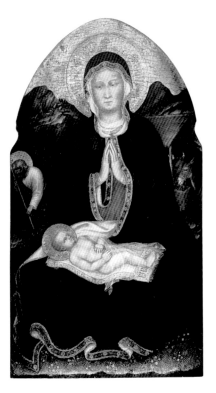

GENTILE DA FABRIANO
AND WORKSHOP
Italian, ca. 1370–1427
The Nativity
ca. 1423–24
Tempera and gold leaf on panel
72 × 42.6 cm (28½ × 16¾ in.)
77.PB.27

THÉODORE GÉRICAULT
French, 1791–1824
The Race of the Riderless Horses
1817
Oil on paper laid on canvas
19.9 × 29.1 cm (7¹³⁄₁₆ × 11⁷⁄₁₆ in.)
85.PC.406

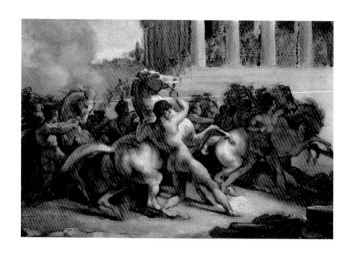

THÉODORE GÉRICAULT
French, 1791–24
Portrait Study
ca. 1818–19
Oil on canvas
46.7 × 38 cm (18³⁄₈ × 15 in.)
85.PA.407

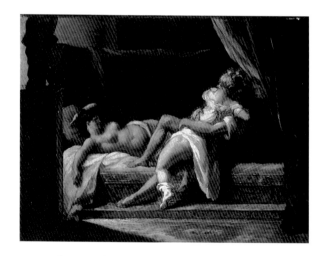

THÉODORE GÉRICAULT
French, 1791–1824
Three Lovers
1817–20
Oil on canvas
22.5 × 29.8 cm (8⅞ × 11¾ in.)
95.PA.72

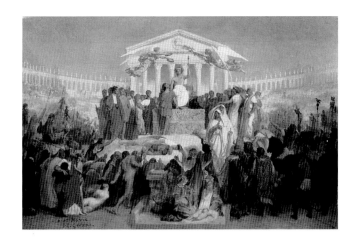

JEAN-LÉON GÉRÔME
French, 1824–1904
*The Age of Augustus,
the Birth of Christ*
ca. 1852–54
Oil on canvas
Signed lower left:
"a mͬ Borie / J.L. Gerome"
37.2 × 55.2 cm (14⅝ × 21¾ in.)
85.PA.226

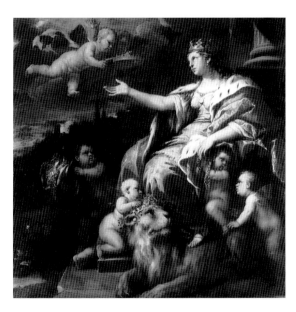

LUCA GIORDANO
Italian, 1632–1705
Allegory
ca. 1670
Oil on canvas
180.3 × 180.3 cm (71 × 71 in.)
69.PA.28

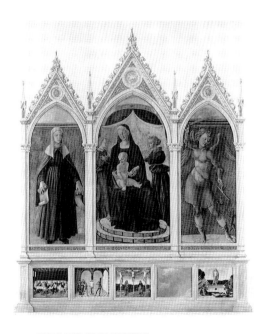

GIOVANNI DI FRANCESCO
Italian, active 1439-1459
*The Madonna and Child with
Saints Bridget and Michael*
1440
Tempera on panel
Central panel: 141 × 72 cm
(55½ × 28⅜ in.)
Side panels each: 131 × 54 cm
(51½ × 21¼ in.)
67.PB.1

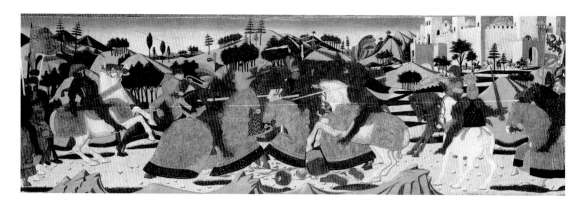

GIOVANNI DI SER GIOVANNI
(CALLED LO SCHEGGIA)
Italian, 1406–1486
Battle Scene
ca. 1450–75
Tempera on panel
42 × 130.2 cm (16½ × 51¼ in.)
71.PB.43

AFTER ANNE-LOUIS GIRODET
DE ROUCY-TRIOSON
French, 1767–1824
The Burial of Atala
ca. 1808
Oil on canvas
Inscribed on back of canvas: "GT"
50.5 × 62 cm (19⅞ × 24⅜ in.)
83.PA.335

GIROLAMO DA CARPI
Italian, ca. 1501–1556
The Holy Family
ca. 1540s
Oil on panel
70 × 52 cm (27½ × 20½ in.)
72.PB.31
(Gift of Burton Fredericksen)

GIROLAMO DEL PACCHIA
Italian, 1477–after 1535
The Rape of the Sabines
ca. 1520
Oil on panel
66 × 144.8 cm (26 × 57 in.)
71.PB.9
(Gift of J. Paul Getty)

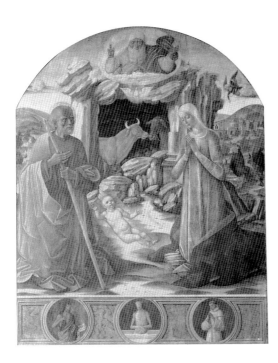

GIROLAMO DI BENVENUTO
Italian, 1470–1524
The Nativity
ca. 1500
Tempera on panel
199.5 × 160 cm (78 ½ × 63 in.)
54.PB.10

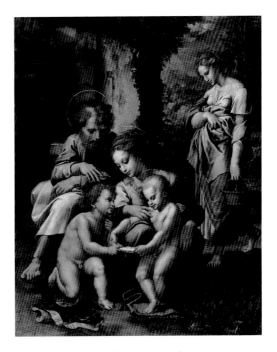

GIULIO ROMANO (GIULIO PIPPI)
Italian, before 1499–1546
The Holy Family
ca. 1520–23
Oil possibly mixed with tempera
on panel
77.8 × 61.9 cm (30 ⅝ × 24 ⅜ in.)
95.PB.64

53

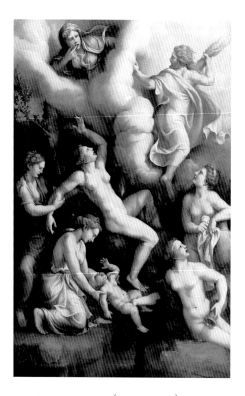

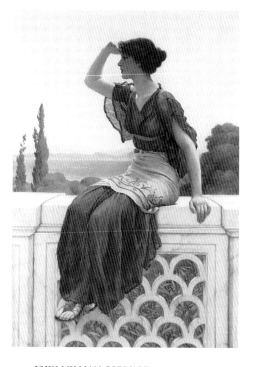

GIULIO ROMANO (GIULIO PIPPI)
AND WORKSHOP
Italian, before 1499–1546
The Birth of Bacchus
ca. 1530s
Oil on panel
126.5 × 80 cm (49 $^{13}/_{16}$ × 31 $^1/_2$ in.)
69.PB.7

JOHN WILLIAM GODWARD
English, 1861–1922
The Signal
1899
Oil on canvas
Signed lower right:
"J.W. Godward. '99"
66 × 46 cm (26 × 18 in.)
79.PA.148

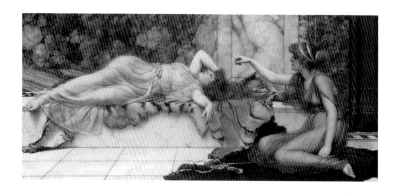

JOHN WILLIAM GODWARD
English, 1861–1922
Mischief and Repose
1895
Oil on canvas
Signed upper left:
".W. Godward 95"
58.5 × 131 cm (23 × 51 $^1/_2$ in.)
79.PA.149

JOHN WILLIAM GODWARD
English, 1861–1922
Reverie
1904
Oil on canvas
Signed lower left:
"J.W. Godward- / 1904"
58.5 × 73.5 cm (23 × 29 in.)
79.PA.150

VINCENT VAN GOGH
Dutch, 1853–1890
Irises
1889
Oil on canvas
Signed lower right:
"Vincent"
71 × 93 cm (28 × 36⅝ in.)
90.PA.20

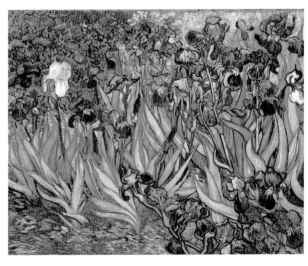

JAN GOSSAERT (CALLED MABUSE)
Netherlandish, ca. 1478–1532
Francisco de los Cobos y Molina
ca. 1530–32
Oil on panel
43.8 × 33.7 cm (17¼ × 13¼ in.)
88.PB.43

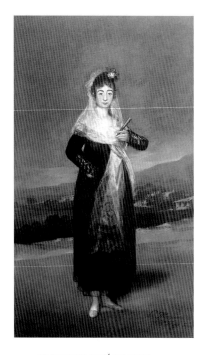

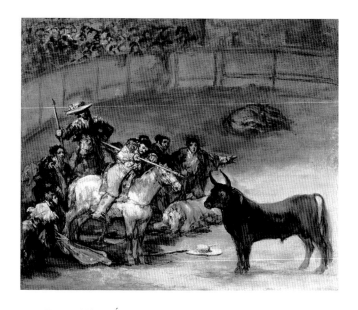

FRANCISCO JOSÉ DE GOYA
Y LUCIENTES
Spanish, 1746–1828
Marquesa de Santiago
1804
Oil on canvas
Signed lower right:
"La Marquesa de Sⁿ Tiago /
Goya 1804"
209.5 × 126.5 cm (82½ × 49¾ in.)
83.PA.12

FRANCISCO JOSÉ DE GOYA
Y LUCIENTES
Spanish, 1746–1828
Bullfight, Suerte de Varas
1824
Oil on canvas
50 × 61 cm (19½ × 24 in.)
93.PA.1

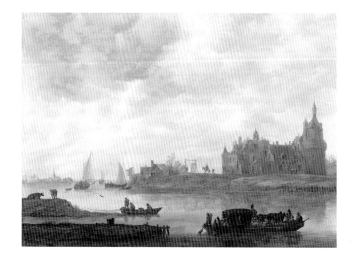

JAN VAN GOYEN
Dutch, 1596–1656
*View of the Castle of Wijk at
Duurstede*
1649
Oil on panel
Signed on boat beneath
carriage: "VG 1649"
52.5 × 73.5 cm (20¾ × 29 in.)
78.PB.198

PIETER DE GREBBER
Dutch, ca. 1600 – ca. 1653
Homage to Bacchus
1628
Oil on canvas
Signed on rim of urn lower left:
"P. DE GREBBER 1628"
124 × 160 cm (48¾ × 63 in.)
71.PA.67

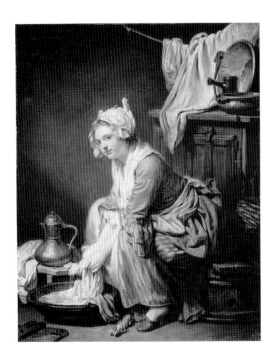

JEAN-BAPTISTE GREUZE
French, 1725 – 1805
The Laundress
1761
Oil on canvas
40.6 × 31.7 cm (16 × 12⅞ in.)
83.PA.387

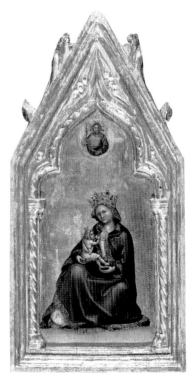

GUARIENTO DI ARPO
Italian, active 1338 – 1367 / 70
The Madonna of Humility
ca. 1345 – 50
Tempera and gold leaf on panel
33 × 17 cm (13 × 6¾ in.)
87.PB.118

GUERCINO (GIOVANNI FRANCESCO
BARBIERI)
Italian, 1591–1666
Pope Gregory XV
ca. 1622–23
Oil on canvas
133.4 × 97.8 cm (52½ × 38½ in.)
87.PA.38

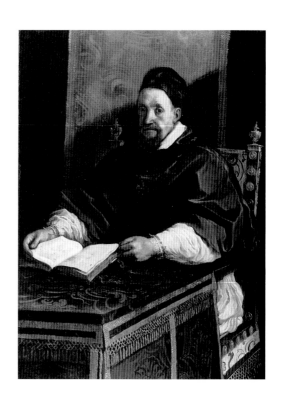

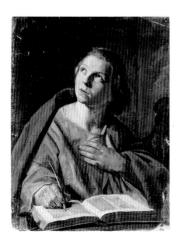

FRANS HALS
Dutch, 1582/1583–1666
Saint John the Evangelist
ca. 1625-1628
Oil on canvas
70.2 × 55.3 cm (27⅝ × 21¾ in.)
97.PA.48

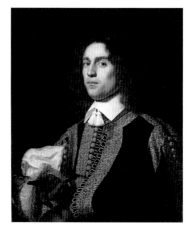

BARTHOLOMEUS VAN DER HELST
Dutch, 1613–1670
*Portrait of a Young Man in
Military Costume*
1650
Oil on canvas
Signed upper left:
"B. van der Helst/1650"
73.5 × 59 cm (29 × 23¼ in.)
70.PA.12
(Gift of J. Paul Getty)

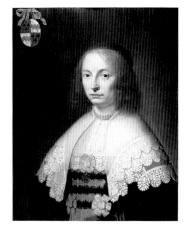

PAULUS HENNEKYN
Dutch, ca. 1611–1672
*Portrait of a Lady of the
Beljaart Family*
ca. 1630s
Oil on panel
70 × 55.5 cm (27½ × 21¼ in.)
78.PB.76

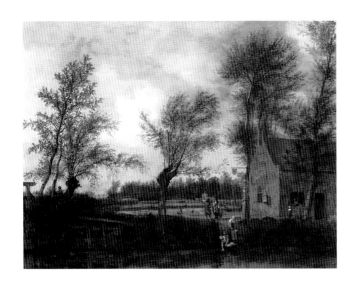

JAN VAN DER HEYDEN
Dutch, 1637–1712
Inn of the Black Pig at
Maarsseveen
ca. 1668
Oil on panel
Signed on upper wooden beam of
embankment: "V Heyde"
46.5 × 60.5 cm (18¼ × 23¾ in.)
78.PB.200

MEINDERT HOBBEMA
Dutch, 1638–1709
A Wooded Landscape
1667
Oil on panel
Signed lower right:
"m. hobbema / f 1667"
61 × 86 cm (24 × 33½ in.)
84.PB.43

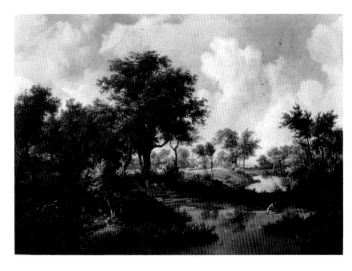

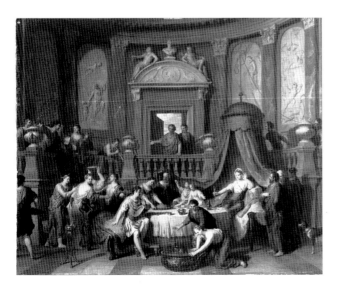

GERARD HOET
Dutch, 1648–1733
The Banquet of Cleopatra
Late 17th–early 18th century
Oil on canvas
57 × 69 cm (22½ × 27¼ in.)
69.PA.14

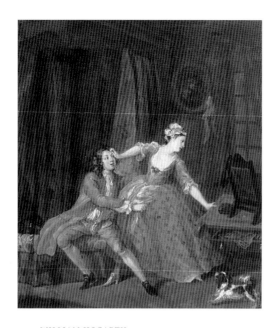

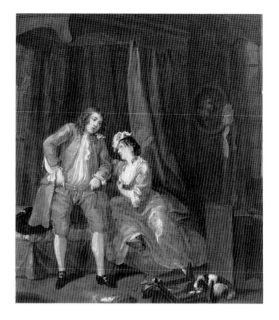

WILLIAM HOGARTH
English, 1697–1764
Before
ca. 1730–31
Oil on canvas
39.5 × 33.5 cm (15¼ × 13¼ in.)
78.PA.204

WILLIAM HOGARTH
English, 1697–1764
After
ca. 1730–31
Oil on canvas
39.5 × 33.5 cm (15¼ × 13¼ in.)
78.PA.205

ATTRIBUTED TO HANS HOLBEIN
THE YOUNGER
German, 1497–1543
An Allegory of Passion
ca. 1520s
Oil on panel
45 × 45 cm (17⅞ × 17⅞ in.)
80.PB.72

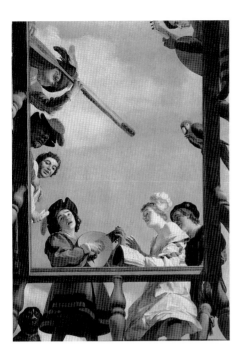

GERRIT VAN HONTHORST
Dutch, 1590–1656
A Musical Group on a Balcony
1622
Oil on panel
Signed on rail beneath music
book held by woman:
"G. Honthorst fe. 1622"
309 × 114 cm (121⅝ × 44⅞ in.)
70.PB.34

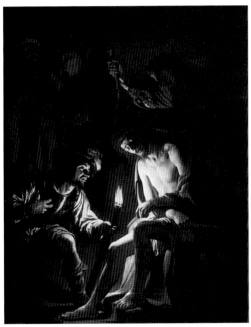

GERRIT VAN HONTHORST
Dutch, 1590–1656
Christ Crowned with Thorns
ca. 1620
Oil on canvas
220.3 × 173.5 cm (87½ × 68⁵⁄₁₆ in.)
90.PA.26

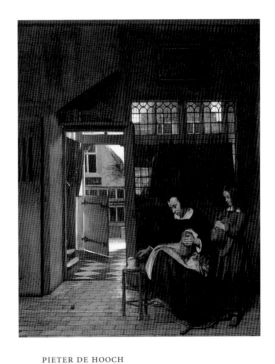

PIETER DE HOOCH
Dutch, 1629–1684
*A Woman Preparing Bread and
Butter for a Boy*
ca. 1660–63
Oil on canvas
Signed lower right: "P. de hooch"
68.3 × 53 cm (26⅞ × 20⅞ in.)
84.PA.47

JACOB VAN HULSDONCK
Flemish, 1582–1647
*Still Life with Lemons, Oranges,
and a Pomegranate*
ca. 1620–40
Oil on panel
Signed: "J.VHVLSDONCK"
42 × 49.5 cm (16½ × 19½ in.)
86.PB.538

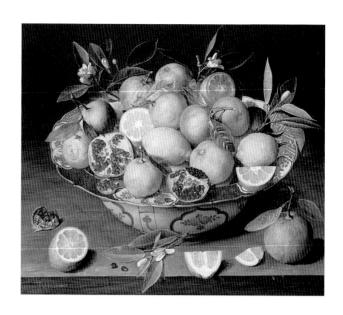

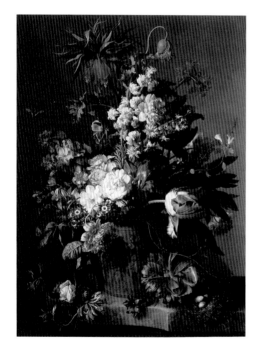

JAN VAN HUYSUM
Dutch, 1682–1749
Vase of Flowers
1722
Oil on panel
Signed lower right:
"Jan van Huysum fecit 1722"
79.5 × 61 cm (31¼ × 24 in.)
82.PB.70

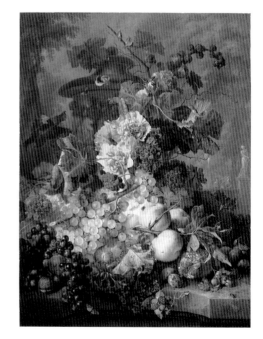

JAN VAN HUYSUM
Dutch, 1682–1749
Fruit Piece
1722
Oil on panel
Signed lower right:
"Jan van Huysum fecit 1722"
79.5 × 61 cm (31¼ × 24 in.)
82.PB.71

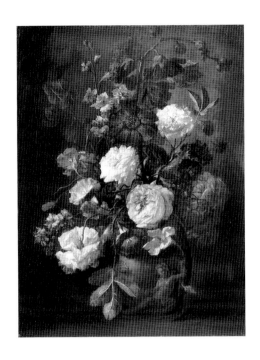

FOLLOWER OF JAN VAN HUYSUM
Dutch, 1682–1749
Vase of Flowers
Mid-18th century
Oil on canvas
54.5 × 41 cm (21½ × 16 in.)
78.PA.66

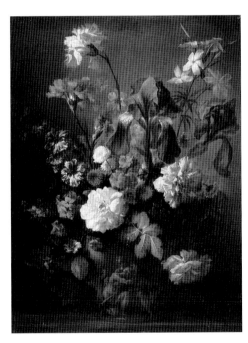

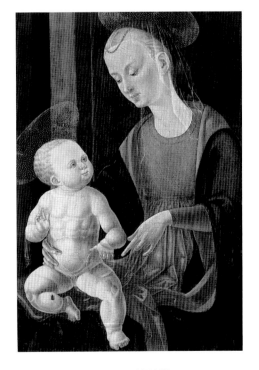

FOLLOWER OF JAN VAN HUYSUM
Dutch, 1682–1749
Vase of Flowers
Mid-18th century
Oil on canvas
54.5 × 41 cm (21½ × 16 in.)
78.PA.67

ITALIAN, FERRARESE SCHOOL,
15TH CENTURY
The Madonna and Child
Second half, 15th century
Tempera on panel
56 × 42 cm (22 × 16½ in.)
70.PB.50

ITALIAN, FERRARESE SCHOOL,
15TH CENTURY
Portrait of a Young Man
Second half, 15th century
Oil possibly mixed with tempera
on panel
22.2 × 16.2 cm (8 5/16 × 6 3/8 in.)
85.PB.233

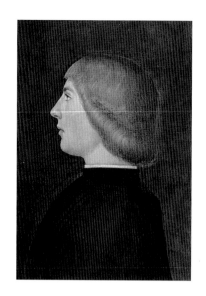

ITALIAN, FLORENTINE SCHOOL,
15TH CENTURY
A Battle before a Walled City
Second half, 15th century
Tempera on panel
43.5 × 165 cm (17 1/8 × 65 in.)
70.PB.27
(Gift of J. Paul Getty)

ITALIAN, NEAPOLITAN OR AVIGNON
SCHOOL, 14TH CENTURY
*The Stigmatization of Saint Francis,
and an Angel Crowning
Saints Cecilia and Valerian*
ca. 1330s
Tempera and gold leaf on panel
Each panel: 31.2 × 22.9 cm
(12 5/16 × 9 in.)
86.PB.490

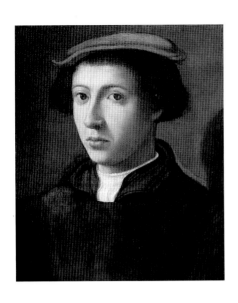

ATTRIBUTED TO DIRCK JACOBSZ.
Dutch, ca. 1497–1567
Portrait of a Young Man
ca. 1530s
Oil on panel
26 × 22.2 cm (10 ¼ × 8 ¾ in.)
54.PB.5
(Gift of Howard Young)

JOHANNES JANSON
Dutch, 1729–1784
A Formal Garden
1766
Oil on canvas
Signed lower left: "J. Jan.... F. ..66"
52 × 72.5 cm (20 ½ × 28 ½ in.)
78.PA.202

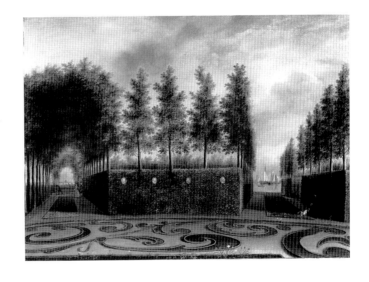

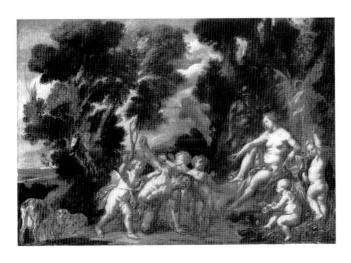

JACOB JORDAENS
Flemish, 1593–1678
Venus and Eros Punishing a Satyr
ca. 1640
Oil on panel
76 × 108 cm (30 × 42 ½ in.)
71.PB.62

JACOB JORDAENS
Flemish, 1593–1678
Moses Striking Water from the Rock
ca. 1645–50
Oil on canvas
130 × 270 cm (51 × 106 in.)
79.PA.136

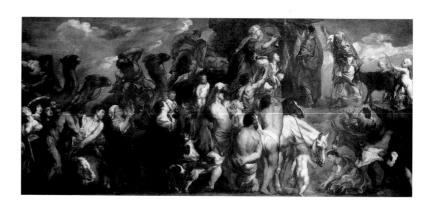

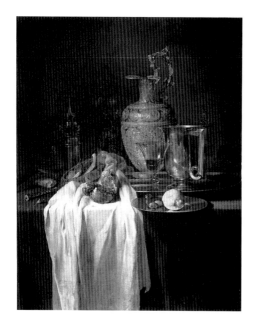

WILLEM KALF
Dutch, 1619–1693
Still Life with Ewer, Vessels, and Pomegranate
Mid-1640s
Oil on canvas
Signed on table edge lower right: "KALF"
103.5 × 81.2 cm (40¾ × 32 in.)
54.PA.1
(Gift of J. Paul Getty)

ATTRIBUTED TO ADRIAEN THOMASZ. KEY
Flemish, ca. mid-1540s–after 1589
Abraham Ortelius
ca. 1570s
Oil on panel
43 × 35 cm (17 × 13¼ in.)
54.PB.2
(Gift of J. Paul Getty)

FERNAND KHNOPFF
Belgian, 1858–1921
Jeanne Kéfer
1885
Oil on canvas
Signed lower center, "Fernand Khnopff
1885"
80 × 80 cm (31½ × 31½ in.)
97.PA.35

LEO VON KLENZE
German, 1784–1864
*Landscape with the Castle of
Massa di Carrara*
1827
Oil on canvas
Signed lower left: "LvKle XXVII"
76.9 × 101 cm (30¼ × 39¼ in.)
86.PA.540

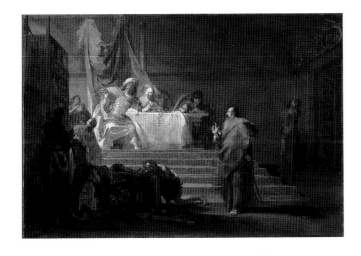

NIKOLAUS KNÜPFER
Dutch, 1603–1655
Solon before Croesus
ca. 1650–52
Oil on panel
Signed lower left: "NKnupfer f."
61 × 90 cm (24 × 35⅜ in.)
84.PB.640

CHRISTEN SCHJELLERUP KØBKE
Danish, 1810–1848
The Forum, Pompeii, with
Vesuvius in the Distance
1841
Oil on canvas
Signed lower right: "C. Købke 1841"
68.5 × 86.3 cm (27⅞ × 34⅝ in.)
85.PA.43

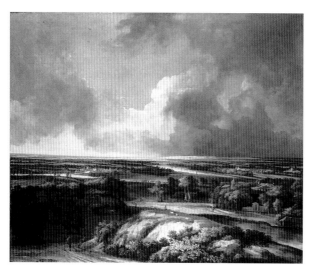

PHILIPS KONINCK
Dutch, 1619–1688
A Panoramic Landscape
1665
Oil on canvas
Signed lower right: "P. Koninck 1665"
138 × 167 cm (54½ × 65½ in.)
85.PA.32

ADÉLAÏDE LABILLE-GUIARD
French, 1749–1803
Delightful Surprise
1779
Pastel on paper
Signed at left above cushion: "Labille f.
Guiard/1779"
54 × 44.5 cm (21½ × 17½ in.)
96.PC.327

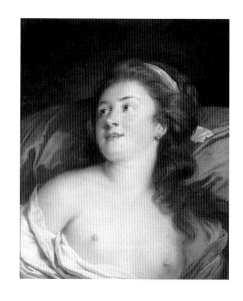

LAURENT DE LA HYRE
French, 1606–1656
Glaucus and Scylla
ca. 1640–44
Oil on canvas
146 × 118.1 cm (57½ × 46½ in.)
84.PA.13

LAURENT DE LA HYRE
French, 1606–1656
*Diana and Her Nymphs in
a Landscape*
ca. 1644
Oil on canvas
Signed right center:
"L. de la Hyre in(v.)
F. 1644"
101 × 134.5 cm (39¾ × 53 in.)
71.PA.41

GIOVANNI LANFRANCO
Italian, 1582–1647
*Moses and the Messengers
from Canaan*
ca. 1621–24
Oil on canvas
218 × 246.3 cm (85¾ × 97 in.)
69.PA.4

GIOVANNI LANFRANCO
Italian, 1582–1647
*Elijah Receiving Bread from
the Widow of Zarephath*
ca. 1621–24
Oil on canvas
225 × 245 cm (80 × 96 in.)
76.PA.1

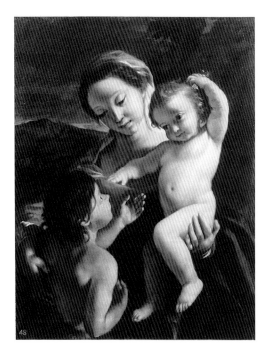

GIOVANNI LANFRANCO
Italian, 1582–1647
*The Madonna and Child with the
Infant Saint John the Baptist*
ca. 1630–32
Oil on canvas
96.6 × 75.5 cm (38 × 29¼ in.)
84.PA.683

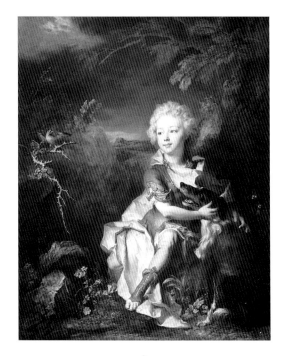

NICOLAS DE LARGILLIÈRE
French, 1656–1746
Portrait of a Boy in Fancy Dress
ca. 1710–14
Oil on canvas
146.1 × 114.9 cm (57½ × 45¼ in.)
71.PA.69

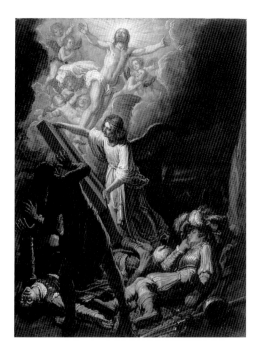

PIETER LASTMAN
Dutch, ca. 1583–1633
The Resurrection
1612
Oil on panel
Signed lower left: "PL...... fecit / ..12"
43.2 × 32.4 cm (17 × 12¾ in.)
87.PB.116

MAURICE-QUENTIN DE LA TOUR
French, 1704–1788
Gabriel Bernard de Rieux,
président à la deuxième chambre
des enquêtes du Parlement de Paris
1739–41
Pastel on gouache on paper
mounted on canvas
317.5 × 223.5 cm (125 × 88 in.)
94.PC.39

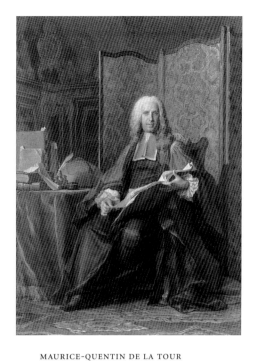

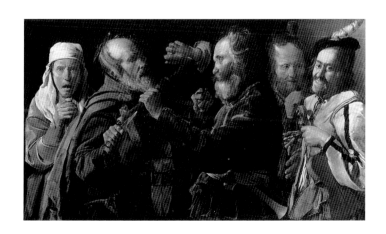

GEORGES DE LA TOUR
French, 1593–1652
The Musicians' Brawl
ca. 1625–30
Oil on canvas
85.7 × 141 cm (33¾ × 55½ in.)
72.PA.28

CHARLES LE BRUN
French, 1619–1690
The Martyrdom of Saint Andrew
1646–47
Oil on canvas
98.5 × 80 cm (38¾ × 31½ in.)
84.PA.669

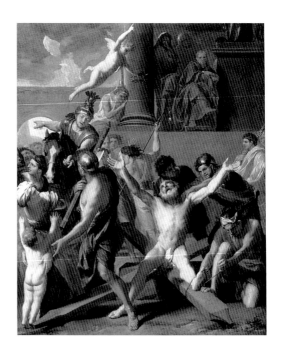

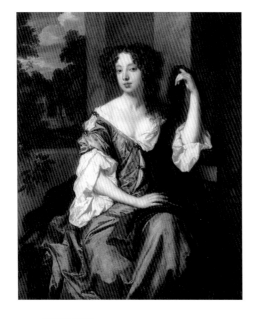

PETER LELY
English, 1618–1680
Louise de Keroualle,
Duchess of Portsmouth
ca. 1671–74
Oil on canvas
122 × 101.5 cm (48 × 40 in.)
78.PA.223

JEAN-BAPTISTE LE PRINCE
French, 1734–1781
The Russian Cradle
ca. 1764–65
Oil on canvas
Signed lower left:
"Jean Baptiste Le Prince 176[?]"
59 × 74 cm (23¼ × 29 in.)
72.PA.23

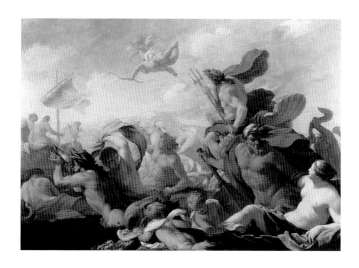

EUSTACHE LE SUEUR
French, 1616–1655
Marine Gods Paying Homage to Love
ca. 1636–38
Oil on canvas
95 × 135 cm (37½ × 53 in.)
72.PA.21

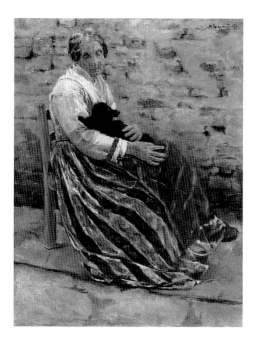

MAX LIEBERMANN
German, 1847–1935
An Old Woman with a Cat
1878
Oil on canvas
Signed upper right:
"M. Liebermann 1878"
96 × 74 cm (37⅞ × 29⅛ in.)
87.PA.6

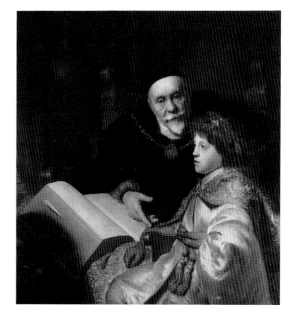

JAN LIEVENSZ.
Dutch, 1607–1674
Prince Charles Louis of the
Palatinate with His Tutor
Wolrad von Plessen in
Historical Dress
1631
Oil on canvas
103.5 × 96.5 cm (40¾ × 38 in.)
71.PA.53

ATTRIBUTED TO JOHANNES
LINGELBACH
Dutch, 1622–1674
Battle Scene
ca. 1651–52
Oil on panel
Signed lower right: "J. Lingelbach"
59.7 × 83.8 cm (23 ½ × 33 in.)
69.PB.5

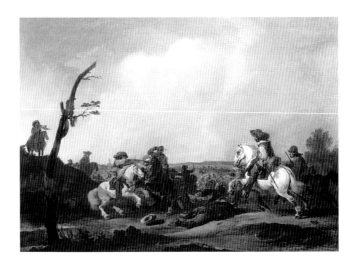

JEAN-ÉTIENNE LIOTARD
Swiss, 1702–1789
*Maria Frederike van
Reede-Athlone at Seven Years
of Age*
1755–56
Pastel on vellum
Signed upper right:
"Peint par / J E Liotard / 1755
& 1756"
57.2 × 47 cm (22 ½ × 18 ½ in.)
83.PC.273

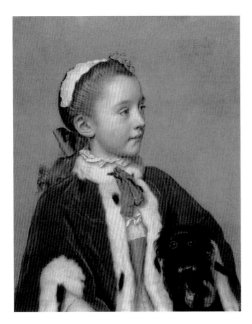

ATTRIBUTED TO JEAN-ÉTIENNE
LIOTARD
Swiss, 1702–1789
Still Life: Tea Set
ca. 1781–83
Oil on canvas mounted on board
37.5 × 51.4 cm (14 ¹³⁄₁₆ × 20 ¼ in.)
84.PA.57

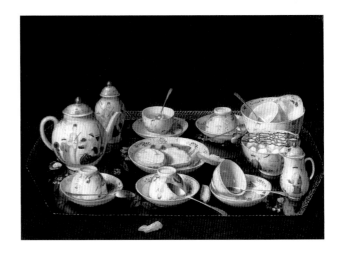

DIRCK VAN DER LISSE
Dutch, active 1635–1669
Landscape with Diana and Actaeon
Mid-17th century
Oil on panel
56 × 85 cm (22 × 32½ in.)
70.PB.9

DIRCK VAN DER LISSE
Dutch, active 1635–1669
Landscape with Bacchanale
Mid-17th century
Oil on panel
78.7 × 149.9 cm (31 × 59 in.)
72.PB.12
(Gift of J. Paul Getty)

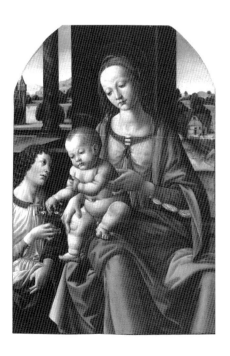

STUDIO OF LORENZO DI CREDI
(LORENZO D'ANDREA D'ODERIGO)
Italian, ca. 1459–1537
The Madonna and Child
ca. 1490–1500
Tempera possibly mixed
with oil on panel
69.5 × 48.2 cm (27⅜ × 19 in.)
70.PB.28
(Gift of J. Paul Getty)

JOHANN CARL LOTH
German, 1632–1698
Susannah and the Elders
Last quarter, 17th century
Oil on canvas
101.5 × 142.2 cm (40 × 56 in.)
69.PA.2

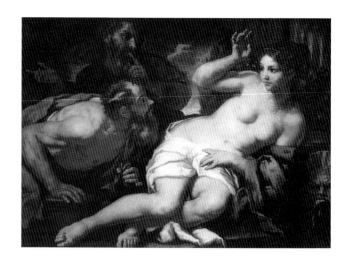

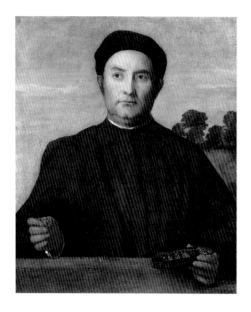

LORENZO LOTTO
Italian, ca. 1480–1556
Portrait of a Jeweller
(Giovanni Pietro Crivelli?)
ca. 1509–12
Oil on canvas
78.7 × 65.7 cm (31 × 25⅞ in.)
70.PA.29
(Gift of J. Paul Getty)

LORENZO LOTTO
Italian, ca. 1480–1556
*The Madonna and Child with
Two Donors*
ca. 1525–30
Oil on canvas
85.7 × 115.5 cm (33¾ × 45½ in.)
77.PA.110

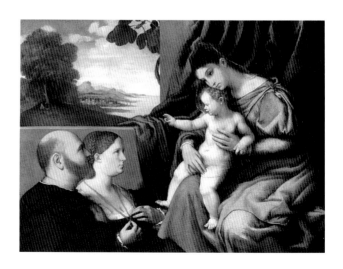

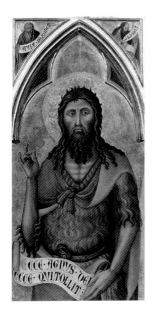

LUCA DI TOMMÈ
Italian, active 1355–1389
Saint John the Baptist
Late 14th century
Tempera and gold leaf
on panel
99.9 × 49.1 cm (39 $\frac{5}{16}$ ×
19 $\frac{5}{16}$ in.)
72.PB.7

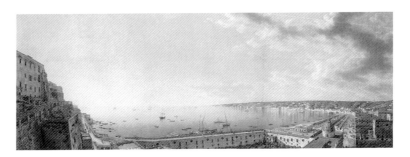

GIOVANNI BATTISTA LUSIERI
Italian, ca. 1755–1821
A View of the Bay of Naples,
Looking Southwest from the
Pizzofalcone toward Capo
di Posilippo
1791

Pen and ink, gouache and
watercolor on six sheets
of paper
Signed lower center edge:
"G.B. Lusier 1791"
102 × 272 cm (40 $\frac{1}{2}$ × 107 in.)
85.GC.281

NICOLAES MAES
Dutch, 1634–1693
The Adoration of the Shepherds
ca. 1660
Oil on canvas
120.6 × 96 cm (47 $\frac{1}{2}$ × 37 $\frac{3}{4}$ in.)
70.PA.38

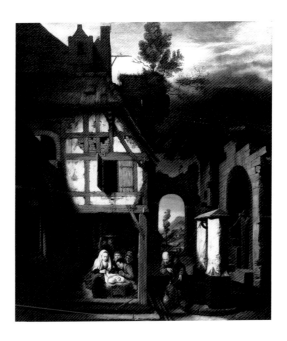

FRANCESCO MAFFEI
Italian, ca. 1605–1660
Rinaldo and the Mirror-Shield
ca. 1650–55
Oil on copper
34.4 × 30.5 cm (12 × 13½ in.)
85.PC.321.1

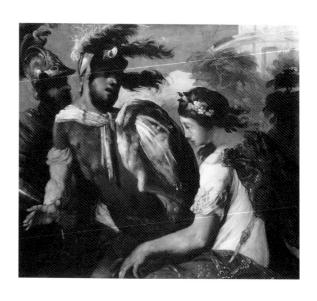

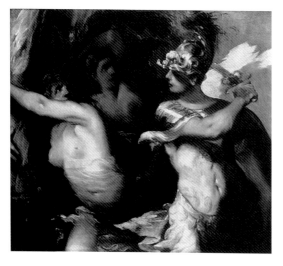

FRANCESCO MAFFEI
Italian, ca. 1605–1660
Rinaldo's Conquest of the
Enchanted Forest
ca. 1650–55
Oil on copper
34.4 × 30.5 cm (12 × 13½ in.)
85.PC.321.2

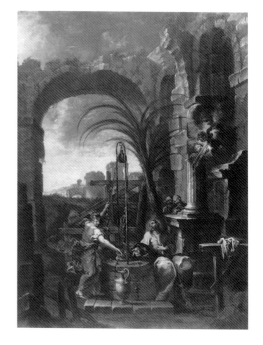

ALESSANDRO MAGNASCO
Italian, 1667–1749
Christ and the Samaritan Woman
ca. 1705–10
Oil on canvas
145 × 109 cm (57 × 43 in.)
73.PA.71

ALESSANDRO MAGNASCO
Italian, 1667–1749
Noli Me Tangere
ca. 1705–10
Oil on canvas
145 × 109 cm (57 × 43 in.)
73.PA.72

ALESSANDRO MAGNASCO
Italian, 1667–1749
Bacchanale
ca. 1720–30
Oil on canvas
118 × 148.5 cm (46½ × 58½ in.)
78.PA.1

ALESSANDRO MAGNASCO
Italian, 1667–1749
The Triumph of Love
ca. 1720–30
Oil on canvas
118 × 148.5 cm (46½ × 58½ in.)
78.PA.2

ATTRIBUTED TO CORNELIS DE MAN
Dutch, 1621–1706
Family Group at the Dinner Table
ca. 1658–60
Oil on canvas
57.5 × 72 cm (22⅝ × 28⅜ in.)
70.PA.20
(Gift of J. Paul Getty)

ÉDOUARD MANET
French, 1832–1883
The Rue Mosnier with Flags
1878
Oil on canvas
Signed lower left:
"Manet 1878"
65.5 × 81 cm (25¾ × 31¾ in.)
89.PA.71

ANDREA MANTEGNA
Italian, ca. 1431–1506
The Adoration of the Magi
ca. 1500
Distemper on linen
48.5 × 65.6 cm (19⅛ × 25⅞ in.)
85.PA.417

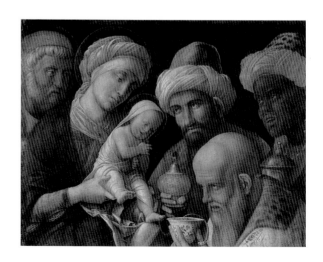

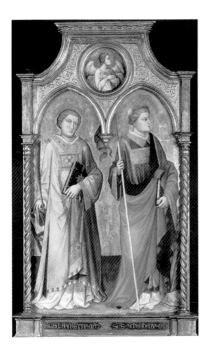

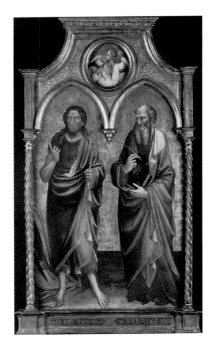

MARIOTTO DI NARDO
Italian, recorded 1394–1424
Saints Lawrence and Stephen
1408
Tempera and gold leaf on panel
99 × 76 cm (39 × 30 in.)
69.PB.30

MARIOTTO DI NARDO
Italian, recorded 1394–1424
*Saints John the Baptist and
John the Evangelist*
1408
Tempera and gold leaf on panel
99 × 76 cm (39 × 30 in.)
69.PB.31

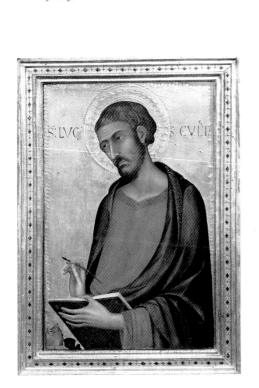

SIMONE MARTINI
Italian, ca. 1284–1344
Saint Luke
ca. 1330s
Tempera and gold leaf on panel
67.6 × 48.3 cm (26 9/16 × 19 in.), with
original engaged frame
82.PB.72

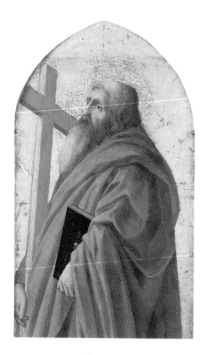

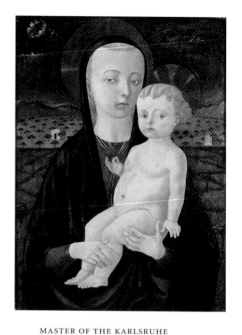

MASACCIO (TOMMASO DI
GIOVANNI GUIDI)
Italian, 1401–1428
Saint Andrew
1426
Tempera and gold leaf on panel
45.09 × 30.8 cm (17¾ × 12⅛ in.)
79.PB.61

MASTER OF THE KARLSRUHE
NATIVITY
Italian, active mid-15th
century
The Madonna and Child
ca. mid-15th century
Tempera on panel
47 × 34 cm (18½ × 13⅜ in.)
70.PB.44

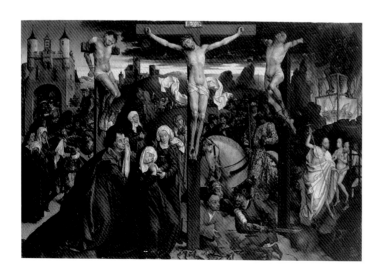

MASTER OF THE PARLEMENT
DE PARIS
French, active ca. 1490s
The Crucifixion
ca. 1490s
Oil on panel
48 × 71.5 cm (18⅞ × 28¼ in.)
79.PB.177

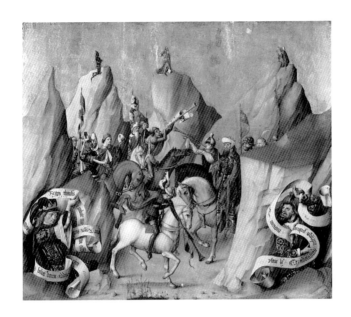

MASTER OF THE ST. BARTHOLOMEW
ALTARPIECE
Netherlandish, active in Cologne
ca. 1480–1510
The Meeting of the Three Kings,
with David and Isaiah (recto) /
Assumption of the Virgin (verso)
Before 1480
Oil and gold leaf on panel
62.8 × 71.2 cm (24¾ × 28⅛ in.)
96.PB.16

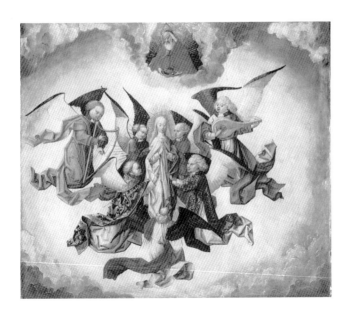

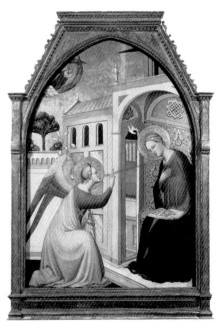

MASTER OF ST. VERDIANA
Italian, active 1370/80–1410/15
The Annunciation
ca. 1410
Tempera and gold leaf on panel
128.2 × 92 cm (50½ × 36¼ in.)
71.PB.21

PAOLO DE' MATTEIS
Italian, 1662–1728
*An Allegory of Divine Wisdom
and the Fine Arts*
1680s
Oil on canvas
Signed lower right:
"Paulus de Mattei F. 168[-]"
356 × 254.5 cm (141½ × 99⅝ in.)
69.PA.20

FRANZ ANTON MAULBERTSCH
Austrian, 1724–1796
*The Glorification of the Union
of the Houses of Hapsburg
and Lorraine*
1775
Oil on canvas
107 × 163 cm (42⅛ × 64⅛ in.)
84.PA.75

BERNARDINO MEI
Italian, ca. 1605–1676
Christ Cleansing the Temple
ca. 1650s
Oil on canvas
104 × 141 cm (41 × 55½ in.)
69.PA.27

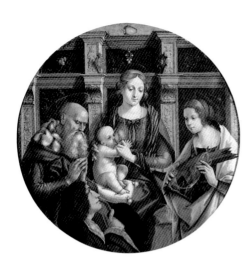

MICHELANGELO DI PIETRO
MENCHERINI (MASTER OF THE
LATHROP TONDO)
Italian, active ca. 1490–ca. 1520
*The Madonna and Child with a
Male Saint, Catherine of
Alexandria, and a Donor*
ca. 1496
Tempera on panel
101.5 cm (40 in.) diameter
68.PB.4

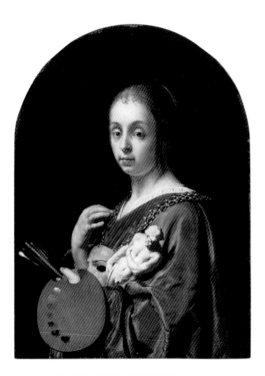

FRANS VAN MIERIS THE ELDER
Dutch, 1635–1681
An Allegory of Painting
1661
Oil on copper
Signed center right:
"F.v.Mieris/Ao 1661"
12.5 × 8.5 cm (5 × 3½ in.)
82.PC.136

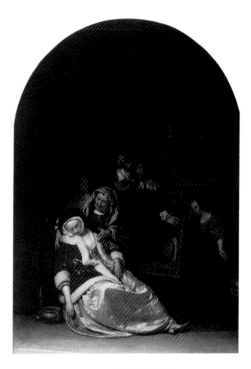

FRANS VAN MIERIS THE ELDER
Dutch, 1635–1681
The Doctor's Visit
1667
Oil on panel
Signed on uppermost rung
of chair: "Frans Mieris /
Ao 1667"
44 × 33 cm (17½ × 12¼ in.)
86.PB.634

JOHN EVERETT MILLAIS
English, 1829–1896
The Ransom
1860–62
Oil on canvas
Signed lower right: "JM 1862"
129.5 × 114.3 cm (51 × 45 in.)
72.PA.13

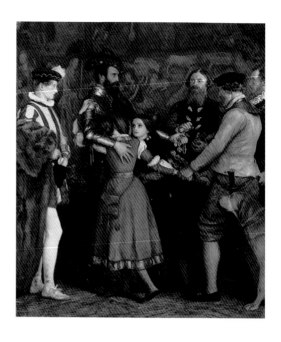

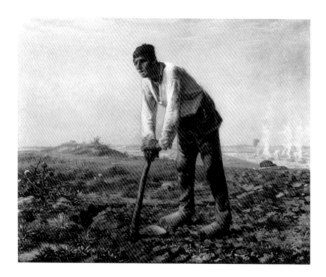

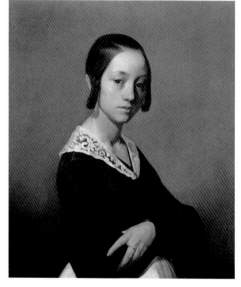

JEAN-FRANÇOIS MILLET
French, 1814–1875
Man with a Hoe
1860–62
Oil on canvas
Signed lower right: "J.F. Millet"
80 × 99 cm (31½ × 39 in.)
85.PA.114

JEAN-FRANÇOIS MILLET
French, 1814–1875
Louise-Antoinette Feuardent
1841
Oil on canvas
Signed lower left: "MILLET"
73.3 × 60.6 cm (28⅞ × 23⅞ in.)
95.PA.67

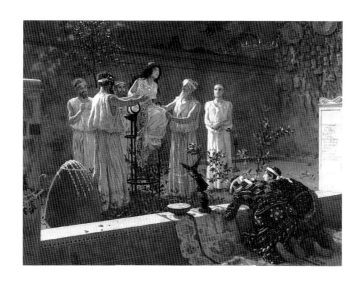

CAMILLO MIOLA (CALLED BIACCA)
Italian, 1840–1919
The Oracle
1880
Oil on canvas
Signed lower left: "C. Miola"
108 × 143 cm (42½ × 56¼ in.)
72.PA.32

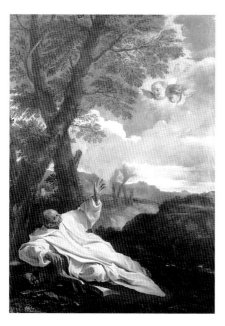

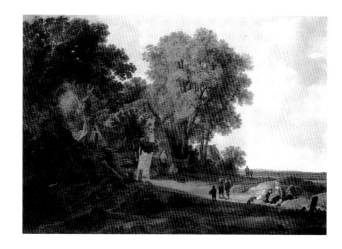

PIER FRANCESCO MOLA
Italian, 1612–1666
The Vision of Saint Bruno
ca. 1660
Oil on canvas
194 × 137 cm (76⅜ × 53⅞ in.)
89.PA.4

PIETER MOLYN
Dutch, 1595–1661
Landscape with Cottage and Figures
ca. 1640
Oil on canvas
137 × 194 cm (54 × 76½ in.)
72.PA.27

CLAUDE MONET
French, 1840–1926
Still Life with Flowers and Fruit
1869
Oil on canvas
Signed upper right: "Claude
Monet"
100 × 80.7 cm (39⅛ × 31¼ in.)
83.PA.215

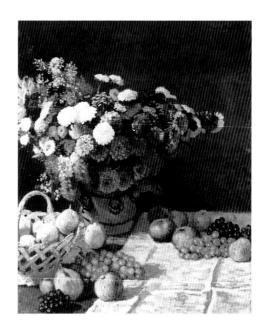

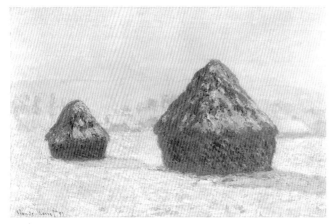

CLAUDE MONET
French, 1840–1926
*Wheatstacks, Snow Effect,
Morning*
1891
Oil on canvas
Signed lower left:
"Claude Monet 91"
65 × 100 cm (25½ × 39¼ in.)
95.PA.63

ATTRIBUTED TO MONOGRAMMIST IS
Dutch, 17th century
Portrait of a Man in a Fur Hat
1638
Oil on panel
Inscribed upper right: "1638"
48 × 38 cm (19 × 15 in.)
70.PB.13
(Gift of J. Paul Getty)

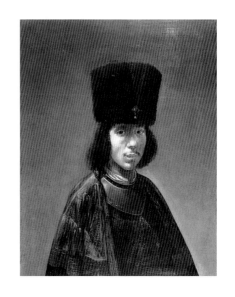

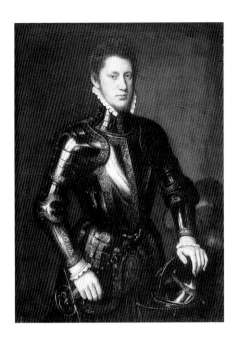

ATTRIBUTED TO ANTONIS MOR
Flemish, 1517–1577
Portrait of a Man in Armor
1558
Oil on canvas
Dated upper left: "1558"
111 × 80 cm (43¾ × 31½ in.)
78.PA.260

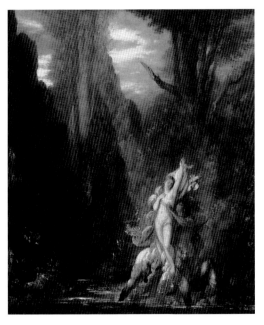

GUSTAVE MOREAU
French, 1826–1898
Autumn (Dejanira)
ca. 1872–73
Oil on panel
Signed lower left: "Gustave Moreau"
55.1 × 45.5 cm (21¹¹⁄₁₆ × 17⁷⁄₈ in.)
84.PB.682

FREDERICK MOUCHERON,
WITH FIGURES ATTRIBUTED TO
ADRIAEN VAN DE VELDE
Dutch, 1633–1686; Dutch, 1636–1672
Italian Landscape with Riders
ca. 1670
Oil on canvas
Signed bottom center:
"Moucheron ft."
139.5 × 117 cm (55 × 46 in.)
78.PA.214

BENJAMIN MUECHER
German, 1959–1992
I'd Like to Swim (*Getty Museum*)
1989
Oil on canvas
110 × 185 cm (43⅓ × 72¹³⁄₁₆ in.)
93.PA.34
(Gift of Erika Rothe)

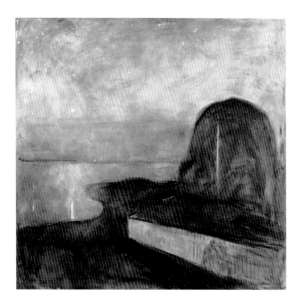

EDVARD MUNCH
Norwegian, 1863–1944
Starry Night
1893
Oil on canvas
Signed lower left: "E Munch"
135 × 140 cm (53⅜ × 55⅛ in.)
84.PA.681

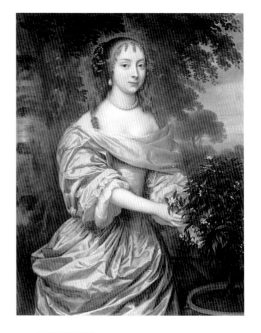

JAN MYTENS
Dutch, ca. 1614–1670
Portrait of a Woman
1660s
Oil on canvas
70 × 57 cm (27½ × 22½ in.)
79.PA.156

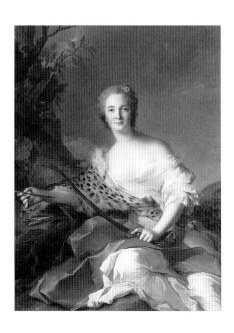

JEAN-MARC NATTIER
French, 1685–1766
Gabrielle Magdeleine Constance
Bonier de la Mosson as Diana
1742
Oil on canvas
Signed lower right: "Nattier p.x.
1742"
128.9 × 96.5 cm (50¾ × 38 in.)
77.PA.87

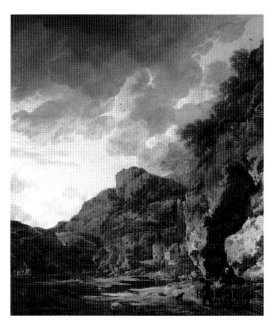

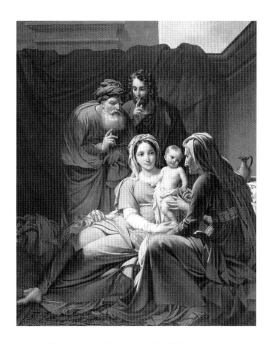

HERMAN NAUWINCX AND
WILLEM SCHELLINKS
Dutch, 1623–after 1654;
Dutch, ca. 1627–1678
Mountain Landscape with
River and Wagon
Third quarter, 17th century
Oil on panel
Signed lower right: "HN" and "WS"
70.5 × 60.5 cm (27½ × 23¾ in.)
69.PB.6

ATTRIBUTED TO FRANÇOIS-JOSEPH
NAVEZ
Belgian, 1787–1869
The Holy Family
ca. 1820s
Oil on canvas
96.5 × 66 cm (38 × 26 in.)
71.PA.32

ATTRIBUTED TO ALEXANDRE-JEAN
NOËL
French, 1752–1834
View of Place Louis XV
ca. 1775–87
Oil on canvas
50 × 75 cm (19⅝ × 29½ in.)
57.PA.3

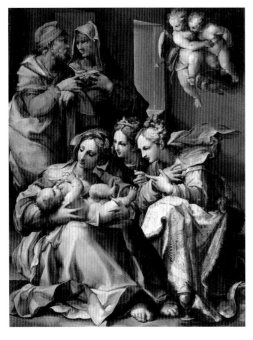

NOSADELLA (GIOVANNI FRANCESCO
BEZZI)
Italian, active ca. 1549–1571
The Holy Family with Saints Anne,
Catherine of Alexandria,
and Mary Magdalen
ca. 1560s
Oil on panel
100.5 × 77.7 cm (39¾ × 30⁹⁄₁₆ in.)
85.PB.310

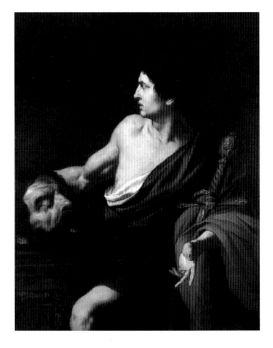

PIETRO NOVELLI
Italian, 1603–1647
David with the Head of Goliath
ca. 1630s
Oil on canvas
126 × 99.5 cm (49½ × 39¼ in.)
72.PA.16

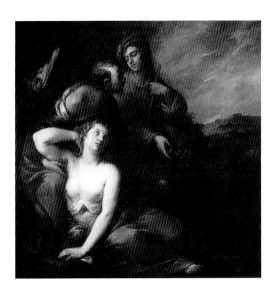

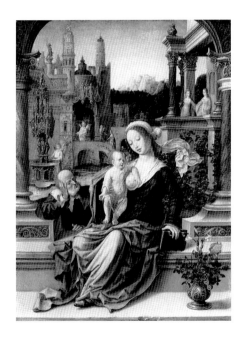

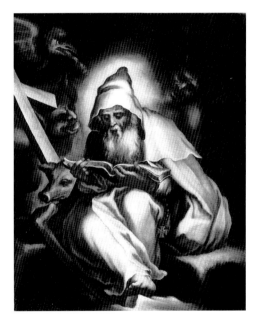

CARLO FRANCESCO NUVOLONE
Italian, 1608 – ca. 1661
Silvio, Dorinda and Linco (?)
ca. 1650
Oil on canvas
172.5 × 174 cm (68 × 68 ½ in.)
69.PA.18

FOLLOWER OF BERNAERT VAN
ORLEY
Netherlandish, ca. 1488 – 1541
The Holy Family
ca. 1520s
Oil on panel
45.5 × 33.5 cm (18 × 13 ¼ in.)
71.PB.45

LELIO ORSI
Italian, 1511 – 1587
The Temptation of Saint Anthony
ca. 1570s
Oil on canvas
44.3 × 36.3 cm (17 ⅜ × 14 ⁵⁄₁₆ in.)
96.PA.10

PACINO DI BONAGUIDA
Italian, documented 1302–ca. 1340
The Chiarito Tabernacle
ca. 1340s
Gilded gesso and tempera
on panel
101.4 × 113.3 cm (39⅞ × 44⅝ in.)
85.PB.311

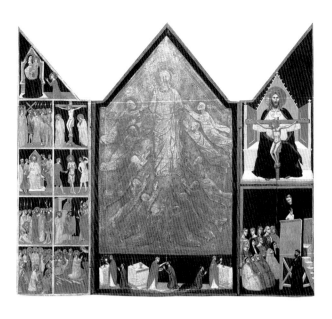

PALMA IL GIOVANE
(JACOPO NEGRETTI)
Italian, 1544–1628
Venus and Mars
ca. 1605–09
Oil on canvas
Signed upper right:
"IACOBVS PAL[MA] P.16[..]"
200 × 110 cm (80⅞ × 56¼ in.)
71.PA.50

PIETRO PAOLINI
Italian, 1603–81
*Achilles among the Daughters
of Lycomedes*
ca. 1625–30
Oil on canvas
127 × 203 cm (50 × 80 in.)
78.PA.363

JEAN-BAPTISTE PERRONNEAU
French, 1715–1783
Charles-François Pinceloup de la Grange
1747, oil on canvas
Signed center right: "Perroneau / 1747 f."
65 × 54.3 cm (25⅝ × 21⅜ in.)
84.PA.664

JEAN-BAPTISTE PERRONNEAU
French, 1715–1783
*Magdaleine Pinceloup de la
Grange, née de Parseval*
1747, oil on canvas
Signed center right: "Perroneau / 1747"
64.8 × 52.6 cm (25⁹⁄₁₆ × 20¹¹⁄₁₆ in.)
84.PA.665

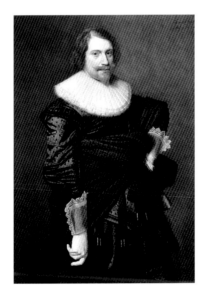

NICHOLAES ELIASZ. PICKENOY
Dutch, 1590/91–1654/56
Portrait of a Man
1632, oil on panel
Inscribed upper right:
"Ætatis suae 2 [7] / Anno.1632"
121.9 × 85.1 cm (48 × 33½ in.)
94.PB.1

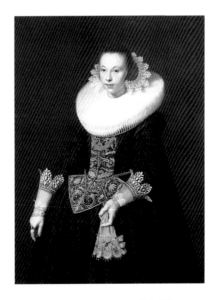

NICHOLAES ELIASZ. PICKENOY
Dutch, 1590/91–1654/56
Portrait of a Woman
1632, oil on panel
Inscribed upper right:
"AEtatis Sua 21 Ano 1632"
118.7 × 90.2 cm (46¾ × 35½ in.)
54.PB.3
(Gift of J. Paul Getty)

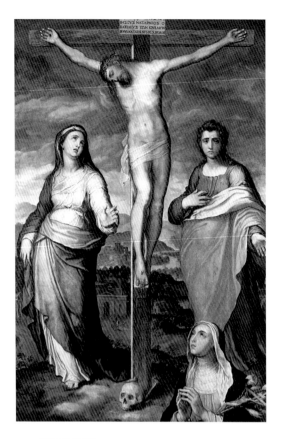

MARCO PINO
Italian, before 1520–1587/88
*Christ on the Cross, with Saints
Mary, John the Evangelist, and
Catherine of Siena*
ca. 1575
Oil on panel
181.5 × 119.5 cm (71½ × 47½ in.)
73.PB.140
(Gift of Alfred S. Karlsen)

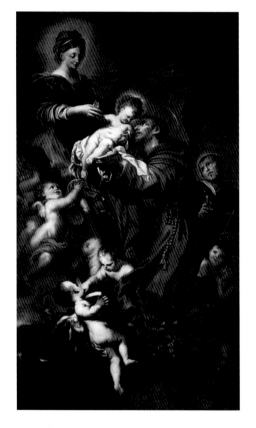

DOMENICO PIOLA
Italian, 1627–1703
*The Madonna and Child Adored
by Saint Francis*
Second half, 17th century
Oil on canvas
290.8 × 172 cm (114½ × 67 in.)
70.PA.43

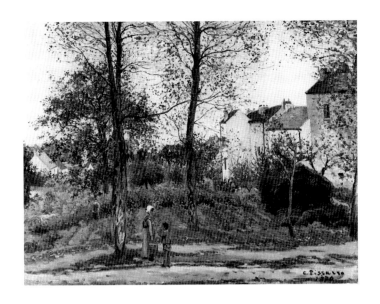

CAMILLE PISSARRO
French, 1830–1903
Landscape in the Vicinity of
Louveciennes (Autumn)
1870
Oil on canvas
Signed lower right: "C. Pissarro /
1870"
89 × 116 cm (35 × 45 ⅕ in.)
82.PA.73

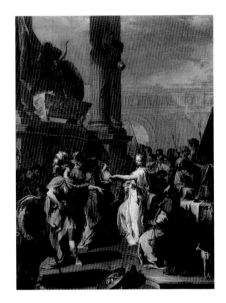

GIOVANNI BATTISTA PITTONI
Italian, 1687–1767
Sacrifice of Polyxena
ca. 1733–34
Oil on canvas
128.3 × 95.3 cm (50 ½ × 37 ½ in.)
72.PA.18

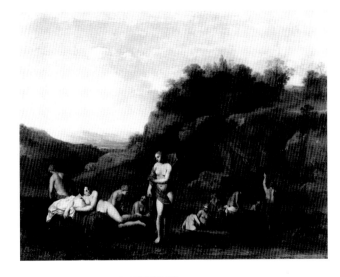

CORNELIS VAN POELENBURGH
Dutch, ca. 1594/95–1667
Landscape with Bathing Nudes
Mid-17th century
Oil on copper
Signed lower left: "CP"
33 × 44 cm (13 × 17 ⅜ in.)
70.PC.10

PONTORMO (JACOPO CARUCCI)
Italian, 1494–1557
Portrait of a Halberdier
(Francesco Guardi?)
ca. 1528–30
Oil possibly mixed with tempera
on panel transferred to canvas
92 × 72 cm (36¼ × 28⅛ in.)
89.PA.49

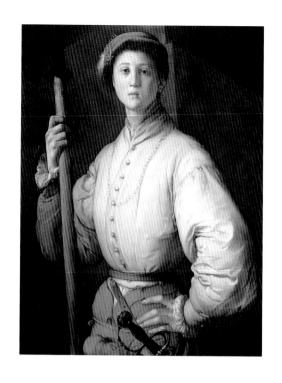

ATTRIBUTED TO PIETER POST
Dutch, 1608–1669
Soldiers Plundering a Village
ca. 1630s
Oil on canvas
77.5 × 112 cm (30½ × 44 in.)
72.PA.26

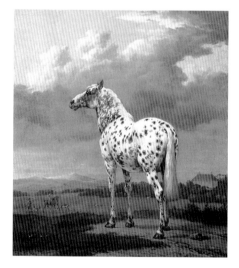

PAULUS POTTER
Dutch, 1625–1654
The Piebald Horse
ca. 1650–54
Oil on canvas
Signed lower left: "Paulus Potter f."
49.5 × 45 cm (19½ × 17¹¹⁄₁₆ in.)
88.PA.87

NICOLAS POUSSIN
French, 1594–1665
Saint John Baptizing in the River Jordan
ca. 1630s
Oil on canvas
95.5 × 121 cm (37⅝ × 47⅝ in.)
71.PA.58

NICOLAS POUSSIN
French, 1594–1665
The Holy Family
ca. 1651
Oil on canvas
100.6 × 132.4 cm (39⅝ × 52⅛ in.)
81.PA.43
(Owned jointly with the Norton
Simon Art Foundation)

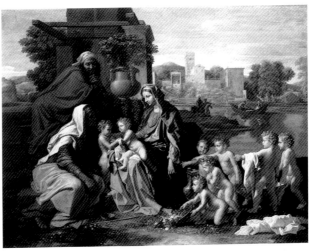

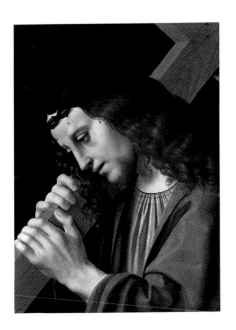

GIOVANNI AMBROGIO DE PREDIS
Italian, ca. 1455–after 1506
Christ Carrying the Cross
ca. 1495–1500
Oil on panel
37 × 27.5 cm (14½ × 10¼ in.)
85.PB.412

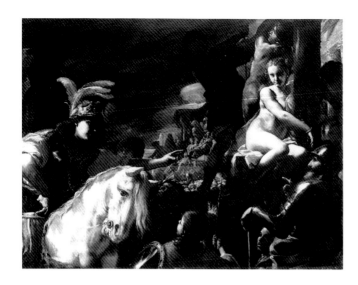

MATTIA PRETI
Italian, 1613–1699
*Clorinda Rescuing Sofronia and
Olindo*
ca. 1660
Oil on canvas
178.5 × 232 cm (70¼ × 91¼ in.)
69.PA.12

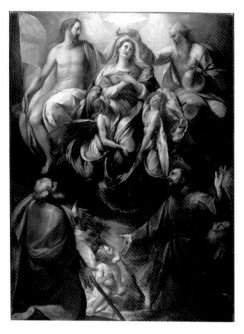

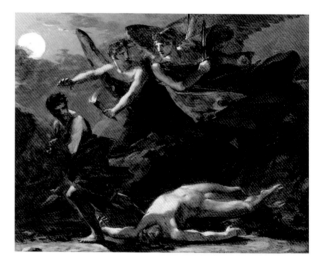

GIULIO CESARE PROCACCINI
Italian, 1574–1625
The Coronation of the Virgin
ca. 1610–20
Oil on panel
97 × 72 cm (38¼ × 28¼ in.)
83.PB.24

PIERRE-PAUL PRUD'HON
French, 1758–1823
*Justice and Divine Vengeance
Pursuing Crime*
ca. 1805–08
Oil on canvas
32 × 41 cm (12⅞ × 16⅛ in.)
84.PA.717

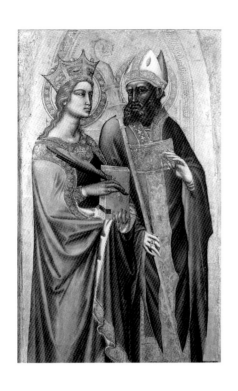

ANGELO PUCCINELLI
Italian, recorded 1380–1407
*Saint Catherine and a Bishop
Saint*
Late 14th century
Tempera and gold leaf on panel
80 × 51 cm (31½ × 20 in.)
70.PB.48

JEAN-BAPTISTE RAGUENET
French, 1715–1793
*View of Paris with the Île de
la Cité*
1763
Oil on canvas
Signed on boat lower center:
"Raguenet 1763"
44.5 × 82 cm (17½ × 32¼ in.)
71.PA.25

JEAN-BAPTISTE RAGUENET
French, 1715–1793
View of Paris from the Pont Neuf
1763
Oil on canvas
Signed lower right:
"Raguenet 1763"
44.5 × 82 cm (17½ × 32¼ in.)
71.PA.26

JEAN RAOUX
French, 1677–1734
Orpheus and Eurydice
ca. 1718–20
Oil on canvas
205.5 × 203 cm (81 × 80 in.)
73.PA.153
(Gift of William P. Garred)

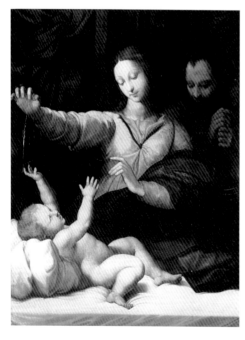

AFTER RAPHAEL
(RAFFAELLO SANZIO)
Italian, 1483–1520
The Holy Family
(The Madonna del Velo;
Madonna di Loreto)
Possibly mid-16th century
Oil on panel
120.5 × 91 cm (47 ½ × 35 ⅞ in.)
71.PB.16
(Gift of J. Paul Getty)

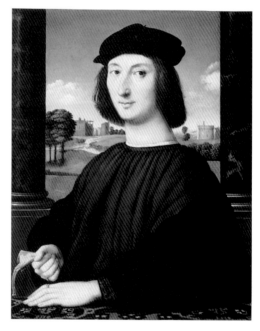

CIRCLE OF RAPHAEL
(RAFFAELLO SANZIO)
Italian, 1483–1520
Portrait of a Young Man in Red
ca. 1505
Oil on panel
67.5 × 53.5 cm (26 ½ × 21 in.)
78.PB.364

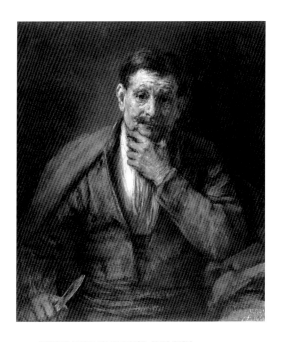

REMBRANDT HARMENSZ. VAN RIJN
Dutch, 1606–1669
Saint Bartholomew
1661
Oil on canvas
Signed lower right:
"Rembrandt. f 1661"
86.5 × 75.5 cm (34⅛ × 29¼ in.)
71.PA.15
(Gift of J. Paul Getty)

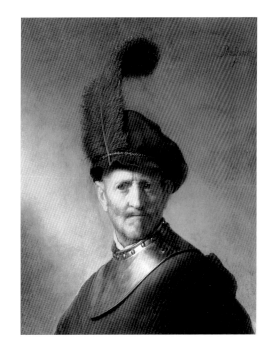

REMBRANDT HARMENSZ. VAN RIJN
Dutch, 1606–1669
An Old Man in Military Costume
ca. 1630–31
Oil on panel
Signed by another hand over original
"RHL" monogram upper right:
"Rembrandt. f."
66 × 50.8 cm (26 × 20 in.)
78.PB.246

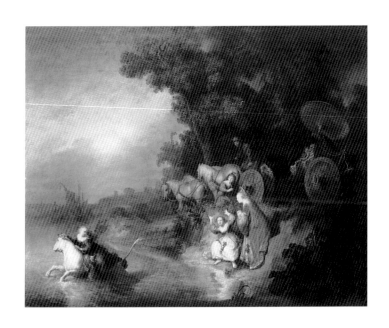

REMBRANDT HARMENSZ. VAN RIJN
Dutch, 1606–1669
The Abduction of Europa
1632
Oil on panel
Signed lower right: "RL.van
Rijn.1632"
62.2 × 77 cm (24½ × 30⁵⁄₁₆ in.)
95.PB.7

REMBRANDT HARMENSZ. VAN RIJN
Dutch, 1606–1669
*Daniel and Cyrus before the
Idol Bel*
1633
Oil on panel
Signed lower right:
"Rembrandt f. 1633"
23.4 × 30.1 cm (9¼ × 11⅞ in.)
95.PB.15

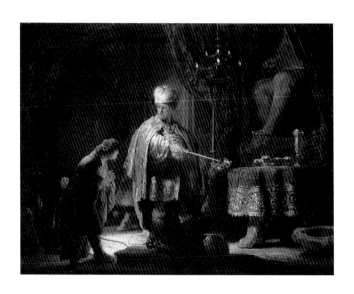

GUIDO RENI
Italian, 1575–1642
*The Virgin and Child with Saint John
the Baptist*
ca. 1640–42
Oil on canvas
172.7 × 142.3 cm (68 × 56 in.)
84.PA.122

GUIDO RENI
Italian, 1575–1642
Joseph and Potiphar's Wife
ca. 1630
Oil on canvas
129 × 170 cm (50¾ × 66¹⁵⁄₁₆ in.)
93.PA.57

PIERRE-AUGUSTE RENOIR
French, 1841–1919
Albert Cahen d'Anvers
1881
Oil on canvas
Signed lower right:
"Renoir Wargemont 9.S^bre.81."
79.8 × 63.7 cm (31⁷⁄₁₆ × 25⅛ in)
88.PA.133

PIERRE-AUGUSTE RENOIR
French, 1841–1919
La Promenade
1870
Oil on canvas
Signed lower left: "A. Renoir. 70."
81.3 × 65 cm (32 × 25½ in.)
89.PA.41

MARCO RICCI AND SEBASTIANO
RICCI
Italian, 1676–1730; Italian,
1659–1734
*Landscape with Classical Ruins and
Figures*
ca. 1725–30
Oil on canvas
123 × 161 cm (48½ × 63½ in.)
70.PA.33

SEBASTIANO RICCI

Italian, 1659–1734

Tarquin the Elder Consulting
Attius Navius

ca. 1690

Oil on canvas

163 × 139 cm (64 × 54½ in.)

72.PA.15

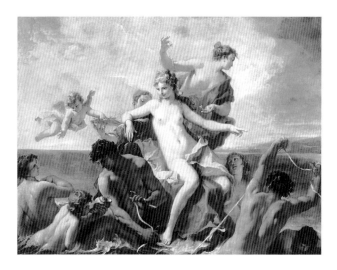

SEBASTIANO RICCI

Italian, 1659–1734

Triumph of the Marine Venus

ca. 1713

Oil on canvas

159.9 × 210.7 cm (63 × 83 in.)

72.PA.29

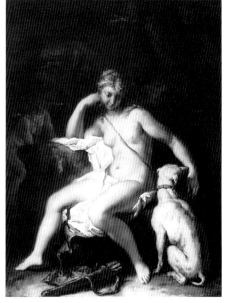

SEBASTIANO RICCI

Italian, 1659–1734

Diana and Her Dog

ca. 1700–05

Oil on canvas

74 × 55.5 cm (29⅛ × 21⅞ in.)

78.PA.230

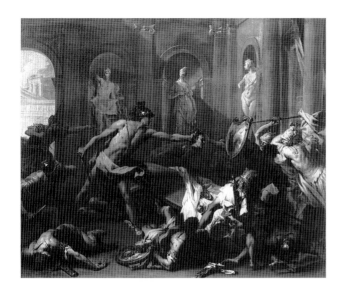

SEBASTIANO RICCI
Italian, 1659–1734
*Perseus Confronting Phineus with
the Head of Medusa*
ca. 1705–10
Oil on canvas
64 × 77 cm (25 3⁄16 × 30 5⁄16 in.)
86.PA.591

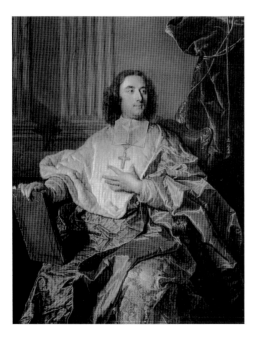

HYACINTHE RIGAUD
French, 1659–1743
*Charles de Saint-Albin,
Archbishop of Cambrai*
1723
Oil on canvas
146 × 113 cm (57 1⁄2 × 44 1⁄2 in.)
88.PA.136

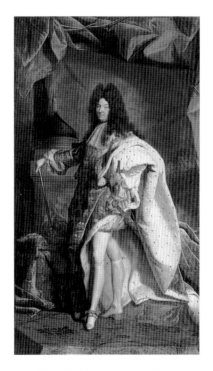

AFTER HYACINTHE RIGAUD
French, 1659–1743
Louis XIV
18th century
Oil on canvas
289.5 × 159 cm (114 × 62 5⁄8 in.)
70.PA.1
(Gift of J. Paul Getty)

HUBERT ROBERT
French, 1733–1808
*A Hermit Praying in the Ruins
of a Roman Temple*
1760s
Oil on canvas
Signed center, on stone wall:
"ROBERT / FECIT / FIO...NT
/ PORT...176__"
59 × 75 cm (23 ¼ × 29 ½ in.)
86.PA.605

MICHELE ROCCA
Italian, 1666–ca. 1730
The Penitent Magdalen
ca. 1698
Oil on canvas
48.2 × 36.2 cm (19 × 14 ½ in.)
77.PA.127
(Gift of William P. Garred)

GEORGE ROMNEY
Scottish, 1734–1802
*Mrs. Anne Horton, later Duchess
of Cumberland*
1788–89
Oil on canvas
136 × 115 cm (53 ½ × 45 ¼ in.)
67.PA.3
(Gift of J. Paul Getty)

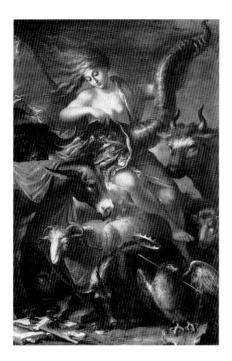

SALVATOR ROSA
Italian, 1615–1673
An Allegory of Fortune
ca. 1658–59
Oil on canvas
Signed lower left: "SR"
198 × 133 cm (78 × 52⅜ in.)
78.PA.231

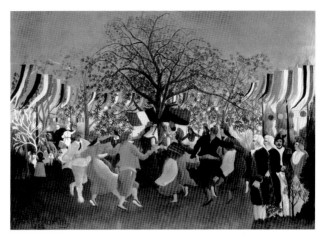

HENRI ROUSSEAU
(CALLED LE DOUANIER)
French, 1844–1910
The Centennial of Independence
1892
Oil on canvas
Signed lower left:
"Henri Rousseau / 1892"
112 × 157 cm (44 × 61⅞ in.)
88.PA.58

PETER PAUL RUBENS
Flemish, 1577–1640
The Virgin as the Woman of the Apocalypse
ca. 1623–24
Oil on panel
64 × 49.5 cm (25 × 19⅖ in.)
85.PB.146

PETER PAUL RUBENS

Flemish, 1577–1640

*Meeting of King Ferdinand of
Hungary and the Cardinal-Infante
Ferdinand of Spain at Nördlingen*

1635

Oil on panel

49.1 × 63.8 cm (19 5/16 × 25 1/8 in.)

87.PB.15

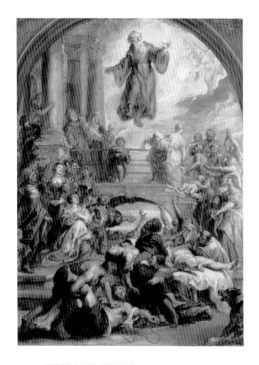

PETER PAUL RUBENS

Flemish, 1577–1640

*The Miracles of Saint Francis
of Paola*

ca. 1627–28

Oil on panel

97.5 × 77 cm (38 3/8 × 30 3/8 in.)

91.PB.50

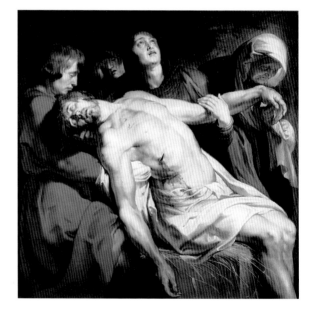

PETER PAUL RUBENS

Flemish, 1577–1640

The Entombment

ca. 1612

Oil on canvas

131 × 130.2 cm (51 5/8 × 51 1/4 in.)

93.PA.9

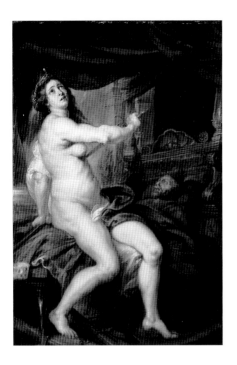

WORKSHOP OF PETER PAUL RUBENS
Flemish, 1577–1640
Death of Dido
ca. 1640
Oil on canvas
183 × 123 cm (72 × 48½ in.)
55.PA.1

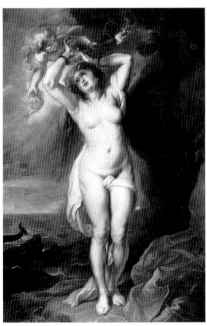

WORKSHOP OF PETER PAUL RUBENS
Flemish, 1577–1640
Andromeda
ca. 1640s
Oil on canvas
197 × 131 cm (77½ × 51½ in.)
57.PA.1

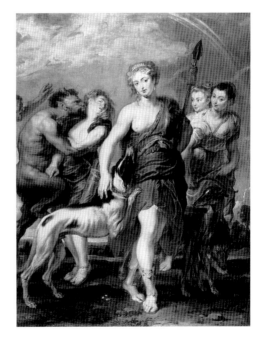

WORKSHOP OF PETER PAUL RUBENS
Flemish, 1577–1640
Diana and Her Nymphs on the Hunt
ca. 1615
Oil on canvas
284 × 180.3 cm (111⅞ × 71 in.)
71.PA.14
(Gift of J. Paul Getty)

WORKSHOP OF PETER PAUL RUBENS
Flemish, 1577–1640
Four Studies of a Male Head
ca. 1617–20
Oil on panel
25.4 × 64.8 cm (10 × 25 ½ in.)
71.PB.39

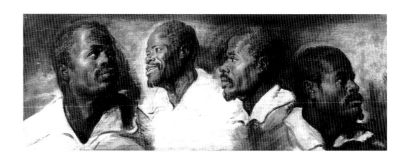

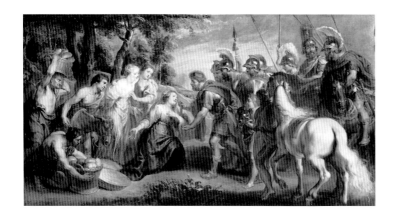

WORKSHOP OF PETER PAUL RUBENS
Flemish, 1577–1640
David Meeting Abigail
ca. 1620s
Oil on canvas
123 × 228 cm (48 ½ × 89 ¾ in.)
73.PA.68

ATTRIBUTED TO PETER PAUL RUBENS
Flemish, 1577–1640
The Death of Samson
ca. 1605–50
Oil on canvas
99 × 110.5 cm (39 × 43 ½ in.)
92.PA.110

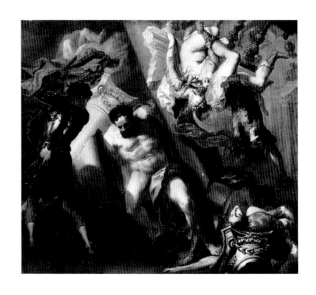

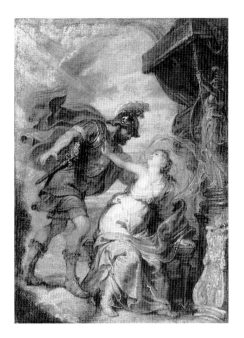

FOLLOWER OF PETER PAUL RUBENS
Flemish, 1577–1640
(Possibly Justus van Egmont, Belgian,
1601–1674)
Mars and Rhea Sylvia
ca. 1620
Oil on canvas
44.5 × 34.3 cm (17 ½ × 13 ½ in.)
73.PA.155
(Gift of Burton Fredericksen)

JACOB VAN RUISDAEL
Dutch, 1628/29–1682
*Two Watermills and an
Open Sluice*
1653
Oil on canvas
Signed lower left: "JVR 1653"
66 × 84.5 cm (26 × 33 ¼ in.)
82.PA.18

JACOB VAN RUISDAEL
Dutch, 1628/29–1682
Landscape with a Wheatfield
ca. late 1650s–early 1660s
Oil on canvas
Signed lower right: "JVRuisdael"
40 × 46 cm (15 ¾ × 18 in.)
83.PA.278

JACOB VAN RUISDAEL
Dutch, 1628/29–1682
The Sluice
ca. 1648–49
Oil on panel
Signed lower left: "JVR"
39.4 × 55.9 cm (15 ½ × 22 in.)
86.PB.597

SALOMON VAN RUISDAEL
Dutch, 1600/03–1670
A View of Rhenen
1660
Oil on canvas
Signed lower left:
"S v Ruysdael 1660"
70.5 × 110.5 cm (27 ¾ × 43 ½ in.)
54.PA.4
(Gift of J. Paul Getty)

SALOMON VAN RUISDAEL
Dutch, 1600/03–1670
Travellers Halting before an Inn
1644
Oil on canvas
Signed lower right:
"S.VRvysdael 1644"
96.5 × 142 cm (38 × 55 ½ in.)
78.PA.196

PIETER JANSZ. SAENREDAM
Dutch, 1597–1665
The Interior of Saint Bavo, Haarlem
1628
Oil on panel
Signed lower right corner:
"P. Saenredam F. AD 1628"
38.5 × 47.5 cm (15 ¼ × 18 ¾ in.)
85.PB.225

GABRIEL DE SAINT-AUBIN
French, 1724–1780
The Country Dance
ca. 1760–62
Oil on canvas
51 × 64.5 cm (20 ⅛ × 25 ⅜ in.)
84.PA.12

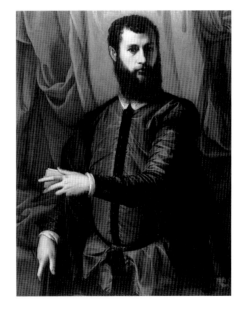

FRANCESCO SALVIATI
(FRANCESCO DE'ROSSI)
Italian, 1510–1563
Portrait of a Man
ca. 1550–55
Oil on panel
108.9 × 86.3 cm (42 ⅞ × 34 in.)
86.PB.476

GIOVANNI GIROLAMO SAVOLDO
Italian, ca. 1480 – after 1548
Shepherd with a Flute
ca. 1525
Oil on canvas
97 × 78 cm (38 3/16 × 30 11/16 in.)
85.PA.162

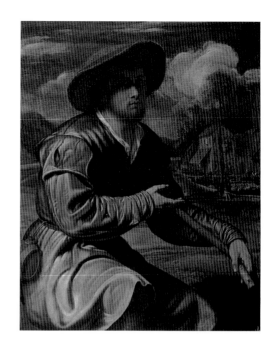

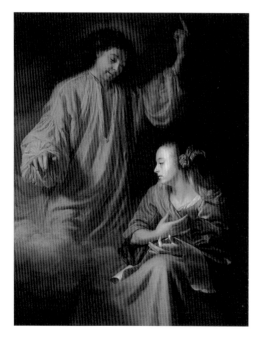

GODFRIED SCHALCKEN
Dutch, 1643 – 1706
The Annunciation
ca. 1660 – 65
Oil on panel
Signed upper left: "G. Schalcken"
26.3 × 20.5 cm (10 3/8 × 8 1/16 in.)
86.PB.464

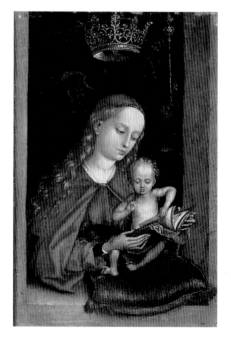

MARTIN SCHONGAUER
German, 1450/53 – 1491
The Madonna and Child in a Window
ca. 1485 – 90
Oil on panel
16.5 × 11 cm (6 1/2 × 4 1/3 in.)
97.PB.23

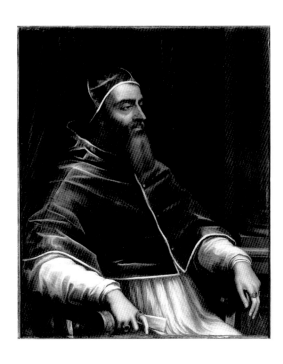

SEBASTIANO DEL PIOMBO
(SEBASTIANO LUCIANI)
Italian, ca. 1485–1547
Pope Clement VII
ca. 1531
Oil on slate
105.5 × 87.5 cm (41½ × 34½ in.)
92.PC.25

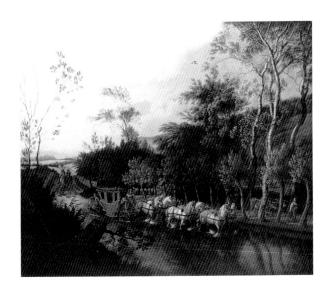

JAN SIBERECHTS
Flemish, 1627– ca. 1703
River Landscape with a Carriage Drawn by Six Horses
ca. 1674
Oil on canvas
Remnants of a signature lower left: "J...e"
81 × 95 cm (32 × 37½ in.)
78.PA.224

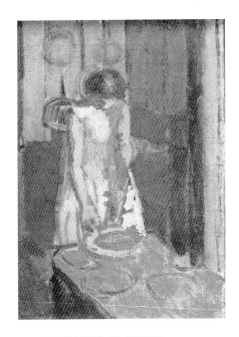

WALTER RICHARD SICKERT
English, 1860–1942
A French Kitchen
ca. 1910–20
Oil on canvas
Signed lower left: "Sickert."
25 × 35 cm (9⅞ × 13⅞ in.)
97.PA.42

MICHAEL SITTOW
Netherlandish, ca. 1469–1525
Portrait of a Man with a Pink
ca. 1500
Oil on panel
25 × 18 cm (9¾ × 7 in.)
69.PB.9

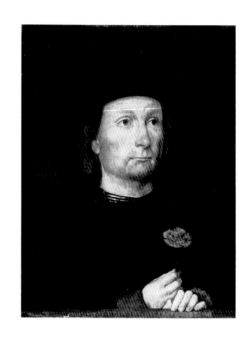

FRANS SNYDERS,
WITH FIGURES ATTRIBUTED
TO JAN BOECKHORST
Flemish, 1579–1657;
Flemish, ca. 1604–1668
*Kitchen Still Life with a Maid
and Young Boy*
Mid-17th century
Oil on canvas
240 × 152.5 cm (94½ × 60 in.)
78.PA.207

FRANCESCO SOLIMENA
Italian, 1657–1747
Death of Messalina
ca. 1708
Oil on canvas
167 × 226 cm (65⅛ × 88⅛ in.)
72.PA.24

FRANCESCO SOLIMENA
Italian, 1657–1747
Venus at the Forge of Vulcan
1704
Oil on canvas
205.5 × 153 cm (80⅞ × 60¼ in.)
84.PA.64

FRANCESCO SOLIMENA
Italian, 1657–1747
*Tithonus Dazzled by the
Crowning of Aurora*
1704
Oil on canvas
202 × 151.2 cm (79½ × 59½ in.)
84.PA.65

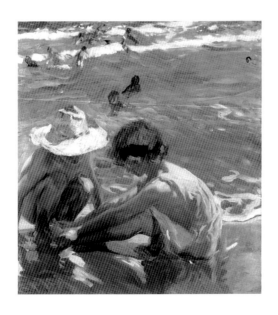

JOAQUÍN SOROLLA Y BASTIDA
Spanish, 1863–1923
The Wounded Foot
1909
Oil on canvas
Signed lower left:
"J Sorolla B 1909"
109 × 99 cm (43 × 39 in.)
78.PA.68

JOAQUÍN SOROLLA Y BASTIDA
Spanish, 1863–1923
*Pepilla the Gypsy and
Her Daughter*
1910
Oil on canvas
Signed lower left:
"J Sorolla 1910"
181.5 × 110.5 cm (71½ × 43½ in.)
78.PA.75

JOAQUÍN SOROLLA Y BASTIDA
Spanish, 1863–1923
*Court of the Dances, Alcázar,
Sevilla*
1910
Oil on canvas
Signed lower right:
"J Sorolla 1910"
95 × 63.5 cm (37½ × 25 in.)
79.PA.151

JOAQUÍN SOROLLA Y BASTIDA
Spanish, 1863–1923
*Hall of the Ambassadors, Alhambra,
Granada*
1909
Oil on canvas
104 × 81 cm (41 × 32 in.)
79.PA.154

JOAQUÍN SOROLLA Y BASTIDA
Spanish, 1863–1923
Corner of the Garden, Alcázar,
Sevilla
1910
Oil on canvas
Signed lower left: "J Sorolla 1910"
95 × 63.5 cm (37½ × 25 in.)
79.PA.155

GHERARDO STARNINA (MASTER OF
THE BAMBINO VISPO)
Italian, active 1378–ca. 1413
The Madonna and Child with
Musical Angels
ca. 1410
Tempera and gold leaf on panel
87.6 × 50.2 cm (34½ × 19¾ in.)
82.PB.108

JAN STEEN
Dutch, 1626–1679
The Satyr and the Peasant Family
ca. 1660–62
Oil on canvas
Signed upper left on fireplace
mantel: "JStein"
51 × 46 cm (20 × 18⅛ in.)
69.PA.15

JAN STEEN
Dutch, 1626–1679
The Drawing Lesson
ca. 1665
Oil on panel
Signed lower left: "JSti__"
49.3 × 41 cm (19⅞ × 16¼ in.)
83.PB.388

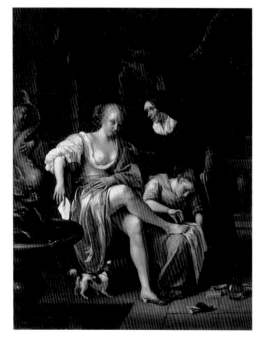

JAN STEEN
Dutch, 1626–1679
Bathsheba after the Bath
ca. 1665–70
Oil on panel
Signed upper left: "JStien"
58 × 45 cm (22⅞ × 17¹¹⁄₁₆ in.)
89.PB.27

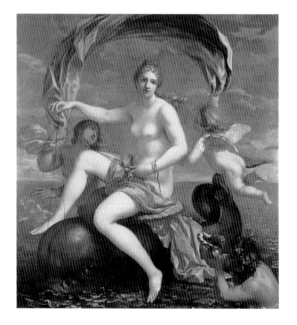

CIRCLE OF JACQUES STELLA
(Possibly Charles-Alphonse
Dufresnoy, French, 1611–1668)
French, 1596–1657
Galatea
Mid-17th century
Oil on canvas
110 × 98 cm (43¼ × 38½ in.)
78.PA.194

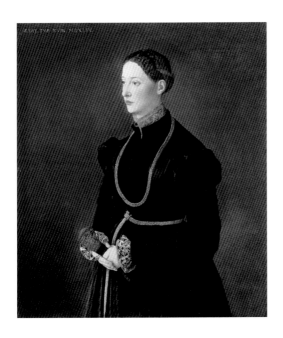

LAMBERT SUSTRIS
Dutch, ca. 1515–1568
Barbara Kressin
1544
Oil on canvas
109.2 × 94 cm (43 × 37 in.)
70.PA.54

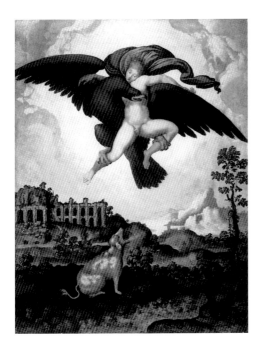

JAN SWART VAN GRONINGEN
Dutch, ca. 1500–1553
The Abduction of Ganymede
ca. 1535–45
Oil on panel
99 × 71 cm (39 × 28 in.)
71.PB.35

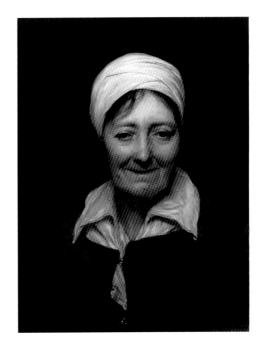

MICHAEL SWEERTS
Flemish, 1618–1664
Head of an Old Woman
ca. 1654
Oil on panel
49.2 × 38.1 cm (19 ⅛ × 15 ¹⁄₁₆ in.)
78.PB.259

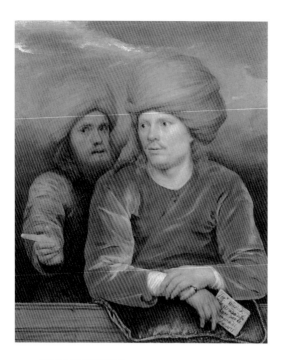

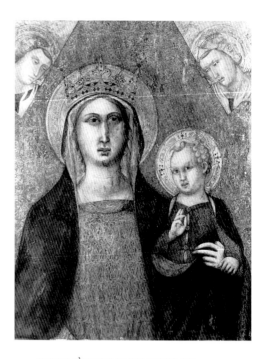

MICHAEL SWEERTS
Flemish, 1618–1664
Double Portrait
ca. 1659–62
Oil on panel
Inscribed lower right on cartellino:
"Sig: 'mio videte / la strada di la /
lute per la / mano di / Sweerts"
21.7 × 17.8 cm (8⁹⁄₁₆ × 7 in.)
85.PB.348

NICCOLO' DI SER SOZZO TEGLIACCI
Italian, active ca. 1350–1363
*The Madonna and Child with Two
Angels*
ca. 1350
Tempera on panel
85.8 × 67.5 cm (33¾ × 26½ in.)
70.PB.49

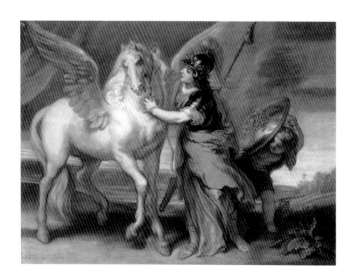

THEODOR VAN THULDEN
Flemish, 1606–1669
Athena and Pegasus
1644
Oil on canvas
Signed lower left:
"T van Thulden fecit A° 1644"
112.5 × 144 cm (44¼ × 58¼ in.)
72.PA.25
(Gift of Dr. Walter S. Udin)

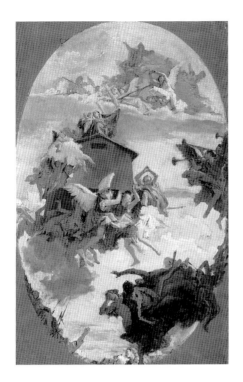

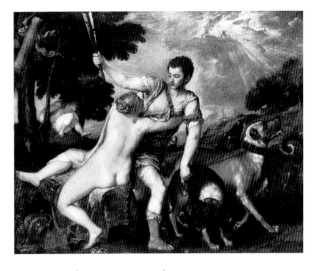

GIAMBATTISTA TIEPOLO
Italian, 1696–1770
*The Miracle of the Holy House
of Loreto*
ca. 1744
Oil on canvas
123 × 77 cm (48 3/8 × 30 3/8 in.)
94.PA.20

TITIAN (TIZIANO VECELLIO)
AND WORKSHOP
Italian, ca. 1480/90–1576
Venus and Adonis
ca. 1555–60
Oil on canvas
160 × 196.5 cm (63 × 77 3/8 in.)
92.PA.42

TITIAN (TIZIANO VECELLIO)
AND WORKSHOP
Italian, ca. 1480/90–1576
The Penitent Magdalen
ca. 1560s
Oil on canvas
106.7 × 98 cm (42 × 36 5/8 in.)
56.PA.1

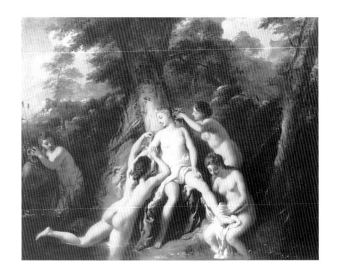

HENRI DE TOULOUSE-LAUTREC
French, 1864–1901
The Model Resting
1896
Tempera or casein with oil
on cardboard
Signed upper right: "HTLautrec"
65.5 × 49.2 cm (25⅝ × 19⅜ in.)
84.PC.39

JEAN-FRANÇOIS DE TROY
French, 1679–1752
Diana and Her Nymphs Bathing
ca. 1722–24
Oil on canvas
73.5 × 92 cm (29¼ × 36⅛ in.)
84.PA.44

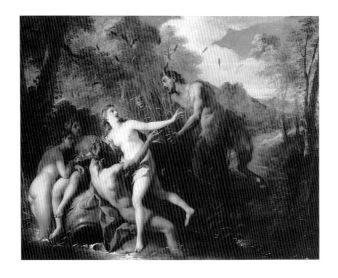

JEAN-FRANÇOIS DE TROY
French, 1679–1752
Pan and Syrinx
ca. 1722–24
Oil on canvas
73.5 × 92 cm (29¼ × 36⅛ in.)
84.PA.45

JEAN-FRANÇOIS DE TROY

French, 1679–1752

Before the Ball

1735

Oil on canvas

Signed lower right:

"De Troy 1735"

81.8 × 65 cm (32⅜ × 25⁹⁄₁₆ in.)

84.PA.668

JOSEPH MALLORD WILLIAM TURNER

British, 1775–1851

Van Tromp, Going about to Please His Masters, Ships a Sea, Getting a Good Wetting

1844

Oil on canvas

91.4 × 121.9 cm (36 × 48 in.)

93.PA.32

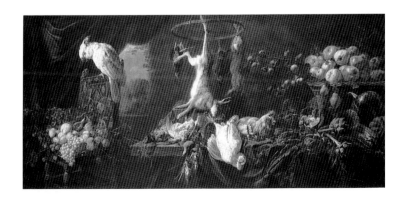

ADRIAEN VAN UTRECHT

Flemish, 1599–1652

Still Life with Game, Vegetables, Fruit, and a Cockatoo

1650

Oil on canvas

Signed on table edge lower left:

"Adriaen van uytrecht. f. 1650"

116.8 × 249 cm (46 × 98¹⁄₁₆ in.)

69.PA.13

VALENTIN DE BOULOGNE
French, 1591–1632
Christ and the Adulteress
ca. 1620s
Oil on canvas
168 × 220 cm (66 × 86½ in.)
83.PA.259

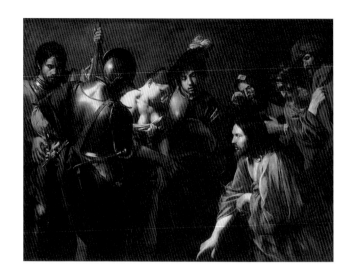

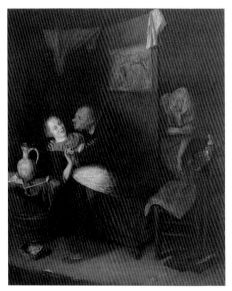

HENDRIK DE VALK
Dutch, active 1692–1717
*Amorous Old Man with a
Young Woman*
ca. 1700
Oil on panel
28 × 23 cm (11 × 9 in.)
78.PB.197

ADRIAEN VAN DE VELDE
Dutch, 1636–1672
*Landscape with Mercury, Argus,
and Io*
1664
Oil on canvas
Signed lower left: "A V Velde / 1664"
68.5 × 89 cm (27 × 25 in.)
78.PA.208

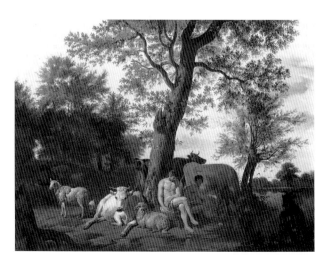

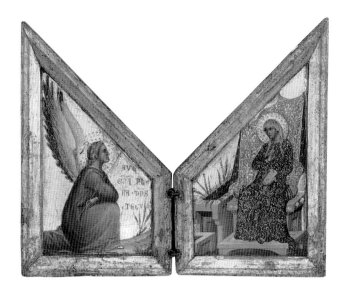

PAOLO VENEZIANO
Italian, active 1333–1358
The Annunciation
ca. 1348–50
Tempera and gold leaf on panel
22.5 × 13.5 cm (8⅞ × 5¼ in.)
87.PB.117

ADRIAEN VAN DE VENNE
Dutch, 1589–1662
Merry Company in an Arbor
1615
Oil on panel
Signed lower center:
"SV VENNE 1615"
16.4 × 23 cm (6⁷⁄₁₆ × 9¹⁄₁₆ in.)
83.PB.364.1

ADRIAEN VAN DE VENNE
Dutch, 1589–1662
*A Jeu de Paume before a
Country Palace*
ca. 1614
Oil on panel
Signed lower center:
"AV V 1614 (?)"
16.5 × 22.9 cm (6½ × 9 in.)
83.PB.364.2

NICOLAS VERKOLYE
Dutch, 1673–1746
Dido and Aeneas
Early 18th century
Oil on canvas
87 × 115 cm (34¼ × 45¼ in.)
71.PA.66

FOLLOWER OF CLAUDE-JOSEPH VERNET
French, 1714–1789
Mediterranean Harbor Scene
1760s
Oil on canvas
Inscribed lower right: "a Roma 176[?]"
96.5 × 134.5 cm (38 × 53 in.)
78.PA.209

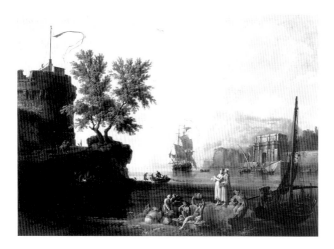

PAOLO VERONESE
(PAOLO CALIARI)
Italian, 1528–1588
Portrait of a Man
ca. 1576–78
Oil on canvas
192.2 × 134 cm (75⅝ × 52¾ in.)
71.PA.17
(Gift of J. Paul Getty)

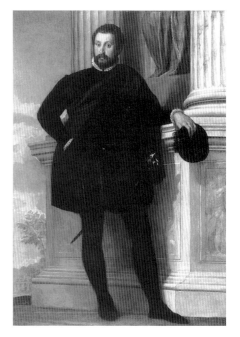

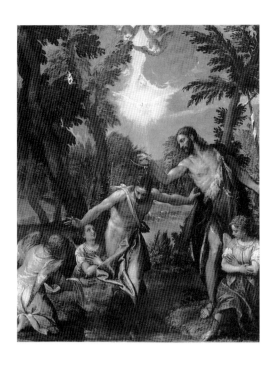

PAOLO VERONESE
(PAOLO CALIARI) AND WORKSHOP
Italian, 1528–1588
The Baptism of Christ
ca. 1580–88
Oil on canvas
108.5 × 89 cm (41¼ × 34¾ in.)
79.PA.19

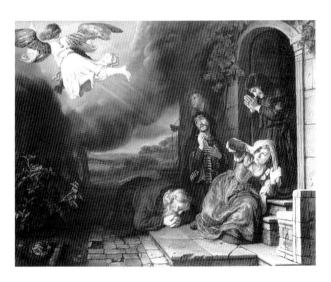

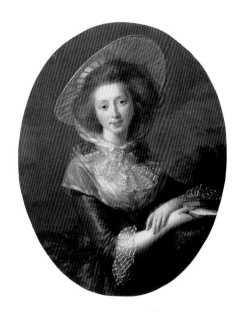

JAN VICTORS
Dutch, 1620–after 1675
*The Angel Taking Leave of
Tobit and His Family*
1649
Oil on canvas
Signed lower right:
"Jan Victors FC 1649"
103.5 × 131.5 cm (40¾ × 51¾ in.)
72.PA.17

ELISABETH LOUISE VIGÉE-LE BRUN
French, 1755–1842
The Vicomtesse de Vaudreuil
1785
Oil on panel
83 × 65 cm (32¾ × 25½ in.)
85.PB.443

BARTOLOMEO VIVARINI
Italian, ca. 1432–1499
*Polyptych with Saint James Major,
The Madonna and Child, and Various
Saints*
1490
Tempera and gold leaf on panel
Inscribed lower center:
"OPVS FACTVM.
VENETIIS PER BARTHOLOMEVM
VIVA/RINVM DE MVRIANO 1490"
280 × 215 cm (110¼ × 84⅝ in.)
71.PB.30

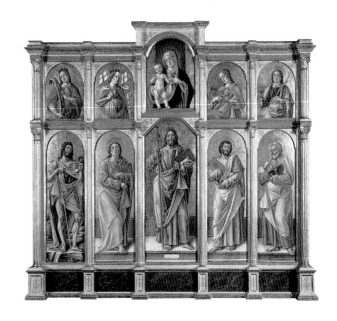

PIERRE-JACQUES VOLAIRE
(CALLED LE CHEVALIER VOLAIRE)
French, 1729–before 1802 (?)
A View of Gaiola
ca. 1770–90
Oil on canvas
Signed bottom center:
"le Che Volaire f"
66 × 96 cm (26 × 37¾ in.)
78.PA.234

PAUL DE VOS
Flemish, 1595–1678
Two Deer Pursued by Hounds
Mid-17th century
Oil on canvas
119.5 × 185.5 cm (47 × 73 in.)
78.PA.206

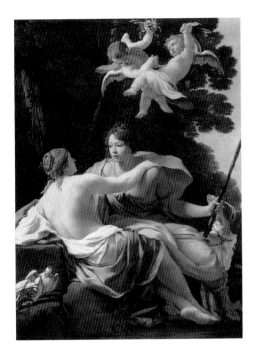

SIMON VOUET
French, 1590–1649
Venus and Adonis
ca. 1642
Oil on canvas
130 × 94.5 cm (51¼ × 37¼ in.)
71.PA.19

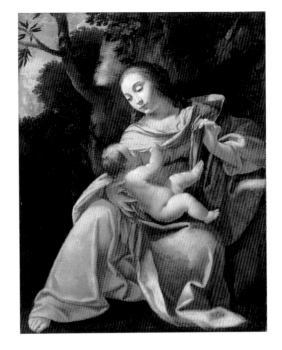

SCHOOL OF SIMON VOUET
French, 1590–1649
The Madonna and Child
Mid-17th century
Oil on canvas
99 × 79 cm (39 × 31 in.)
68.PA.1

JACOBUS VREL
Dutch, active 1654–1662
A Street Scene
ca. 1654–62
Oil on panel
41 × 34.2 cm (16¼ × 13½ in.)
70.PB.21
(Gift of J. Paul Getty)

JACOBUS VREL
Dutch, active 1654–1662
The Little Nurse
ca. 1654–62
Oil on panel
56 × 41.5 cm (22 × 16⅜ in.)
71.PB.61

WORKSHOP OF ROGIER VAN DER
WEYDEN
Netherlandish, 1399/1400–1464
The Dream of Pope Sergius
ca. 1440s
Oil on panel
89 × 80 cm (35 × 31½ in.)
72.PB.20

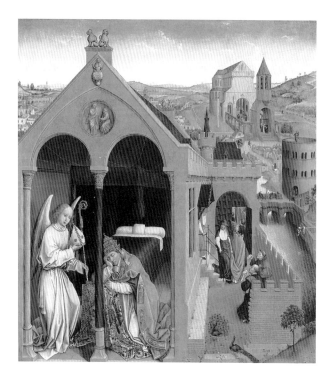

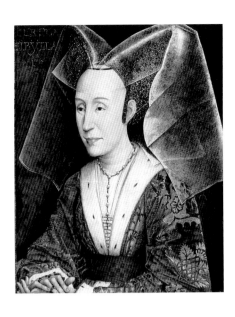

AFTER ROGIER VAN DER WEYDEN
Netherlandish, 1399/1400–1464
Isabella of Portugal
ca. 1500
Oil on panel
47 × 38 cm (18⅝ × 14⁷⁄₃₂ in.)
78.PB.3

FOLLOWER OF ROGIER VAN
DER WEYDEN
Netherlandish, 1399/1400–1464
The Deposition
ca. 1490
Oil and gold leaf on panel
61 × 99.7 cm (24 × 39¼ in.)
79.PB.20

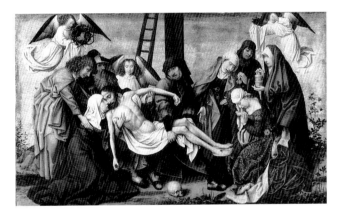

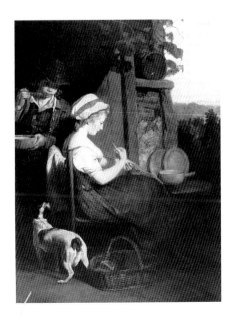

FRANCIS WHEATLEY
English, 1747–1801
The Industrious Cottager
1786
Oil on canvas
Signed lower right: "F. Wheatley"
184 × 136.5 cm (72½ × 53¾ in.)
78.PA.210

JACQUES WILBAULT
French, 1729–1806
Presumed Portrait of the Duc de Choiseul and Two Companions
ca. 1775
Oil on canvas
Signed lower right: "J. Wilbaut"
87.6 × 114.3 cm (34 ½ × 45 in.)
71.PA.68

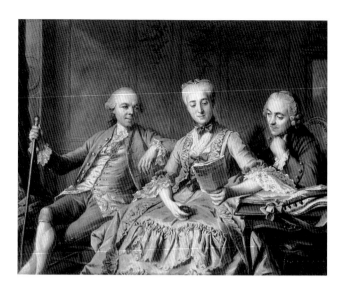

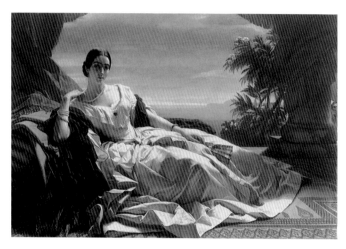

FRANZ XAVER WINTERHALTER
German, 1805–1873
Leonilla, Princess of Sayn-Wittengenstein-Sayn
1843
Oil on canvas
Signed center right: "Winterhalter / Paris / 1843"
142 × 212 cm (56 × 83 ½ in.)
86.PA.534

JOSEPH WRIGHT OF DERBY
English, 1734–1797
John Whetham of Kirklington
ca. 1779–80
Oil on canvas
127 × 101.6 cm (50 × 40 in.)
85.PA.221

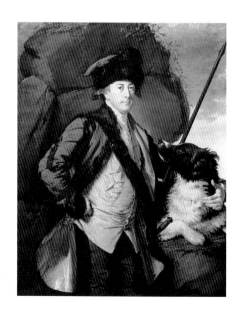

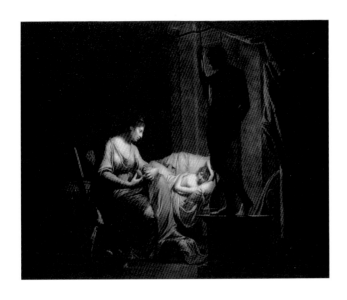

JOSEPH WRIGHT OF DERBY
English, 1734–1797
Penelope Unravelling Her Web
1783–84
Oil on canvas
105.7 × 131.4 cm (41⅝ × 51¾ in.)
87.PA.49

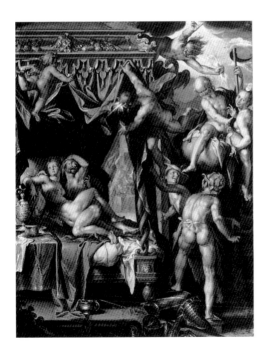

JOACHIM ANTHONISZ. WTEWAEL
Dutch, 1566–1638
Mars and Venus Surprised by Vulcan
ca. 1606–10
Oil on copper
Signed lower right:
"JOACHIM WTEN / WAEL FECIT"
20.25 × 15.5 cm (8 × 6⅛ in.)
83.PC.274

ADRIEN YSENBRANDT
Netherlandish, active 1510–1551
The Mass of Saint Gregory the Great
1510–50
Oil on panel
28 × 36.2 cm (14¼ × 11½ in.)
69.PB.11

BERNARDINO ZENALE
Italian, ca. 1456–1526
*The Madonna Adoring the Child
with Musical Angels*
ca. 1500–10
Oil on panel
143 × 85.5 cm (56½ × 33¾ in.)
71.PB.60

JOHANN ZOFFANY
German, 1733–1810
*John, 14th Lord Willoughby de Broke,
and His Family in the Breakfast
Room at Compton Verney*
ca. 1766
Oil on canvas
100.5 × 125.5 cm (39½ × 49½ in.)
96.PA.312

FRANCESCO ZUCCARELLI
Italian, 1702–1778
*Landscape with the Education
of Bacchus*
1744
Oil on canvas
Signed lower left: "Francesco
Zuccarelli 1744 fece"
130 × 150 cm (51 × 59 in.)
79.PA.137

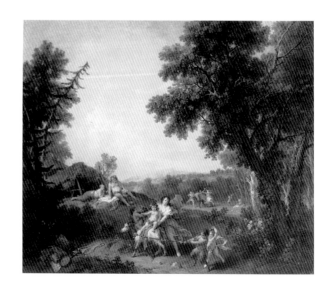

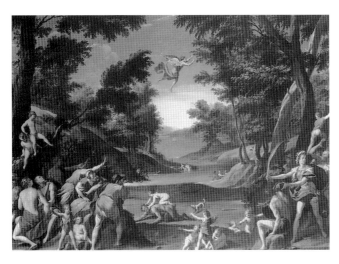

ATTRIBUTED TO FEDERICO ZUCCARO

Italian, ca. 1541–1609

Cupid and Pan

ca. 1600

Oil on canvas

73.7 × 100 cm (29 × 39 ¼ in.)

72.PA.6